IMAGES
of America

NEVILLE ISLAND

On the cover: Please see page 19. (Courtesy of Neville Green.)

IMAGES of America
NEVILLE ISLAND

Gia Tatone and Dan Holland
with Neville Green

Copyright © 2008 by Gia Tatone and Dan Holland with Neville Green
ISBN 978-0-7385-6344-2

Published by Arcadia Publishing
Charleston SC, Chicago IL, Portsmouth NH, San Francisco CA

Printed in the United States of America

Library of Congress Catalog Card Number: 2008927791

For all general information contact Arcadia Publishing at:
Telephone 843-853-2070
Fax 843-853-0044
E-mail sales@arcadiapublishing.com
For customer service and orders:
Toll-Free 1-888-313-2665

Visit us on the Internet at www.arcadiapublishing.com

This book is dedicated to Amelia Horak, Neville Island's true and foremost historian, for her lifelong efforts in being the protector and keeper of this delicate history.

Contents

Acknowledgments 6

Introduction 7

1. Early History 9
2. Market Basket of Pittsburgh 17
3. God's Spirit 27
4. Education 35
5. Island Industry 49
6. A River Story 63
7. Neville Island Sports and Recreation 73
8. People and Places of the Island 85

Acknowledgments

I would like to offer gracious thanks to Dorothy Antonelli, president of Neville Green. Your valiant efforts for this island and its environment are commendable beyond words. Your dedication and hard work are inspiring to many. I would like to honorably mention founder Neville Green, Eileen Hutchinson, as well as Sandra Martin, Susan McCoy, Sandy Lang, June Withrow, and Ruby (Horak) Davis for much-needed project support. Thank you also to Todd Phillips and Bob MacDowell for providing us with the means and space to work.

Very special thank you goes to Jim Fiedler for hours of searching to obtain rare and never-before-seen photographs that were imperative to this project. Your passion for this island is respected. Vicki Fiedler, thank you for your kindness, humor, and generosity towards me. Thank you also to your children, Shawn, Stephanie, Marissa, and Wyatt, who have patiently endured.

My deepest thanks go to my coauthor, colleague, and friend, Dan Holland. Your tireless, persevering efforts, which you freely and willingly gave to find the truth to this island's past, are a treasure to this land. It is an honor being on this journey with you, and I could not have done this book without you. Thank you also for giving me a chance when others did not, for believing in me, and for trusting me with your organization. You are a true, living example of a good leader, teacher, and Good Samaritan. Thank you also to your family, Kasia, Konrad, and Adela, for their patience and gentleness.

To Frank, my forever love, your undying support to my endless endeavors and continual pioneering efforts penetrates my heart. Thank you for believing in me and supporting me to the very edges of the earth. To my daughter, Amelia, my only child, you are my precious gift. Many years ago, Neville Island was entrusted to a girl named Amelia, the only child of the man who pioneered the island. Each generation since then has been gifted by endeavors of women named Amelia. May you continue a legacy like those whose name you carry. I love you.

Most importantly, I want to thank God for the miracle he performed in my life on May 8, 2005, from which the spark to start the fire that burns within me for this and all my endeavors originated.

Finally, I wish to thank all the generous residents of both the island and surrounding community for your precious photographs and memories. All information has been obtained by reviewing detailed recording keeping and stories from people like you. If any of the information is inaccurate, or if there are any errors, please accept my deepest apologies.

—Gia Tatone

INTRODUCTION

Neville Island's history is the story of resilient residents who endured floods, rapid industrialization, land struggles, and even "Poison Park." But it is also a story of people with a proud but untold history that includes an extensive agrarian legacy, lost Coney Island Park, and community rebirth. Long before Neville Island assumed its current industrial reputation, the island supported lush farms through the mid-20th century and was known as the "Gem of the Ohio." In the 1700s, Neville Island was referred to by three separate names: Montour's Island (after the French-Canadian Montour family, which owned the land), Hamilton's Island, and Long Island.

Gen. John Neville assumed ownership of the land in 1800. Virginia-born Neville served with both George Washington and Gen. Edward Braddock during the French and Indian War. Neville was the commandant at Fort Pitt when fighting for the Revolutionary War broke out, where he served as the colonel of the 4th Virginia Regiment. Neville and his son Presley (born 1755) were captured in the battle of Charleston in 1780. They were released two years later. When the war concluded, Neville was awarded a promotion to brigadier general in 1783. Then-president Washington appointed Neville an inspector of revenue under the excise laws of 1791 that were necessary to pay for the Revolutionary War. The protest of this tax led to the Whiskey Rebellion of 1794. Following that incident, Neville retreated to his Woodville Plantation near modern-day Bridgeville, south of Pittsburgh.

While Neville never lived on his namesake island, his only daughter, Amelia (born 1763), resided there with her husband, Revolutionary War soldier Capt. Isaac Craig, in the early 1800s. Neville died on Neville Island on July 29, 1803, presumably at his daughter's house, and was buried at Trinity Church Cemetery in downtown Pittsburgh until his grave was moved to Allegheny Cemetery, where it remains today. It is possible that a number of foreign dignitaries may have visited Neville Island. The 1908 book, *A Century and a Half of Pittsburg and Her People*, by John Newton Boucher, notes that King Louis XVIII of France and the Marquis de Lafayette, while fleeing Napoleon, spent a night at Presley's home in downtown Pittsburgh and may have spent time at the Craig home on Neville Island. Presley served as an aide-de-camp for Lafayette, an acquaintance of Louis XVIII.

As the population of Neville Island grew in the early to mid-1800s, residents established the island's first institutions: a public school, built in 1842, and the Presbyterian church, organized on May 6, 1843. On April 8, 1856, the island was incorporated as Neville Township. Until World War I, Neville Island's farms were nationally known, earning a reputation as the "Market Basket of Pittsburgh."

Bridges constructed in 1894 enabled Neville Island to transform from a farming community to an island of industry. The first factories were developed in 1900 on what was lush farmland. Development of a proposed munitions plant for World War I required government seizure of 130 acres of land. The war ended abruptly and the plant was never built, but farmers were unable to out-bid U.S. Steel Corporation to get their land back. The conversion of the island from "Gem of the Ohio" to floating factory had begun. Neville Island was also noted for its recreation. An amusement park, Coney Island Park, opened on the island in 1907. However, no accounts of the park could be found after 1910, and it faded into obscurity.

Neville Island continued to grow and thrive. A new school building was erected in 1915. The island's only religious congregation, the Neville Island Presbyterian Church, constructed a new Romanesque structure in 1917. On January 1, 1922, Neville Township was declared a first-class township. The Ohio River played a key role in Neville Island's history. It served as a source of transportation, recreation, and fear of floods, the worst of which devastated the island in 1936.

Despite the devastation of floods and the loss of land, the Neville Island community began to flourish during World War II with companies like the Dravo Corporation, the largest inland boat works in the United States, and Pittsburgh Coke and Chemical Company, employing thousands. Residents built new houses, and they opened additional markets, retail shops, and bars—as many as 14 operated on the island during the 1950s and 1960s. In 1976, a bridge was constructed across the island for the new Interstate 79 that connected Washington with Erie. A year later, toxic chemicals were found at the western tip of the island as Allegheny County was preparing the 32-acre site for a park. The area, dubbed "Poison Park," never opened. The toxins were encapsulated, and the land was redeveloped as the Island Sports Center, now operated by Robert Morris University. Today Neville Island is a diverse community of industry, river-front residences, and recreation. Struggles over land are a vestige of the past. Gone also is the island's farming reputation that led to its national acclaim. Residents find much pleasure in the quiet island lifestyle, with the river never too far away.

One

EARLY HISTORY

Neville Island's history in the mid-1700s began with an ownership dispute. Referred to as Hamilton's Island and Long Island, Neville Island was commonly called Montour's Island after Henry Montour, an interpreter of French and Native American descent, who owned the land. Maj. William Douglas, a British field officer during the French and Indian War, was given a grant of 5,000 acres that included Montour's Island in the Treaty of Paris in 1763. Douglas assigned the land to Col. Charles Sims on January 17, 1779, when Pittsburgh was still part of Virginia. However, the supreme executive council of Pennsylvania conferred the island upon Gen. William Irvine (1741–1804) in 1783 for his services during the Revolutionary War. Sims contested the decision.

After a protracted legal battle, the U.S. Supreme Court decided in favor of Sims in February 1799. Gen. John Neville (1731–1803), who had surveyed the land in the 1770s, bought portions of the land from Sims. Neville was the commandant at Fort Pitt in 1775 and served in the Revolutionary War as colonel of the 4th Virginia Regiment. At the end of the war, Neville was awarded a promotion to brigadier general. In July 1794, while serving as inspector of internal revenue for western Pennsylvania, rural land owners, angry with a tax rate levied on distilled spirits that was higher in the west than those in the east, rose up and burned Neville's mansion, Bower Hill, to the ground in what became known as the Whiskey Rebellion. Neville Island was finally conferred to Neville on September 3, 1800.

Neville deeded the island to his only daughter, Amelia, who lived on the island in the early 1800s. Neville died on his namesake island in 1803, most likely at his daughter's house. On April 8, 1856, the island was incorporated as a separate municipality, named Neville Township in honor of the general. From its earliest days until World War I, Neville Island remained a quiet and peaceful farming community.

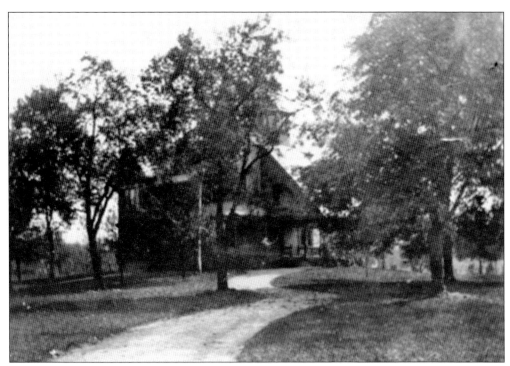

One of the early families to settle on Neville Island, the Pittocks, lived in this house in the early 1900s. This home stood on the northeastern end of the island.

Thomas Ralph Pittock was in the oil business and also worked in real estate when he purchased this Neville Island house in 1882. He married Emma E. Burns of Franklin in 1870.

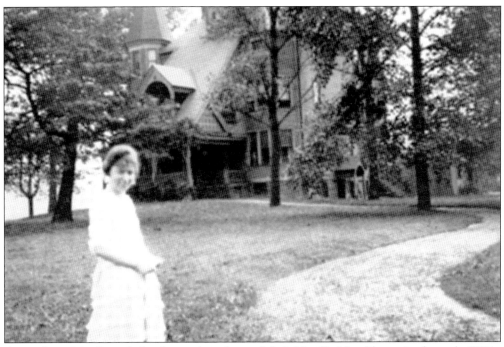

A member of the Pittock family stands in front of their Neville Island home in the early 1900s.

A very sad incident occurred on Neville Island when the Pittocks lost four of their children to drowning in the Ohio River on June 17, 1892.

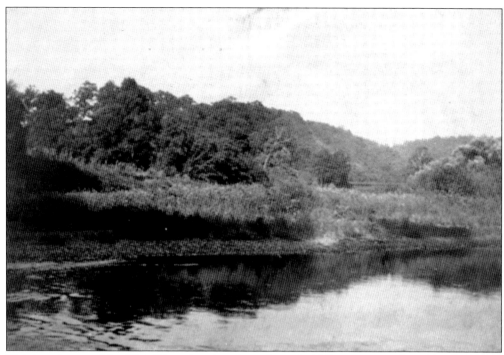

This is an image of the Ohio River shoreline from the early 1900s just across from Neville Island, showing the undeveloped nature of the river valley.

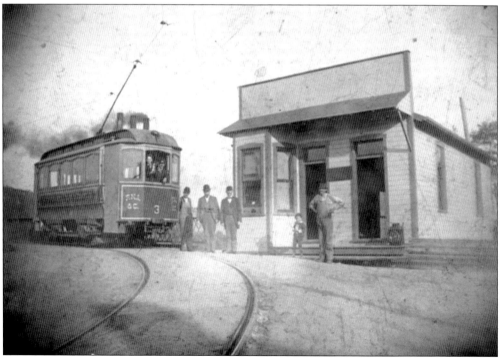

Trolley service to Neville Island began in 1894 upon the completion of the Coraopolis-Neville Island Bridge.

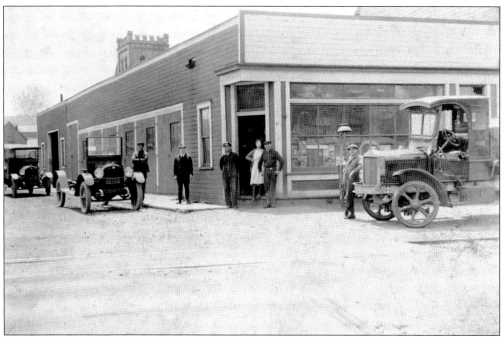
This photograph illustrates one of the early stores on Neville Island, most likely in the early 1920s. The island's church, seen in the background, was constructed in 1917. This spot is occupied by present-day Gino's Restaurant, which opened in 1954.

By 1947, most of the early farmhouses from the island's agrarian past had been lost.

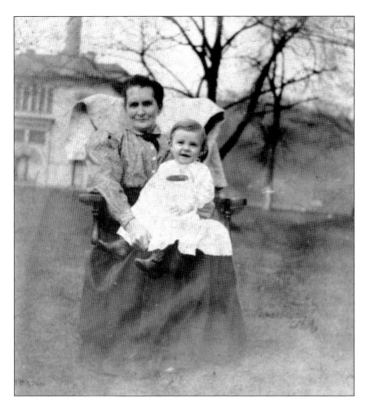

Longtime Neville Island resident Margaret Watters Gibson is seen here with James Neville Firestone in 1910. The lock house is seen in the background.

In 1916, members of the Withrow family posed for a photograph in front of their Neville Island home.

The Kleiman family of Neville Island is pictured here in front of their home in the early 1900s.

Families enjoyed outdoor dining in clean air on Neville Island in the 1920s. Most of the industrial pollution from Pittsburgh traveled east.

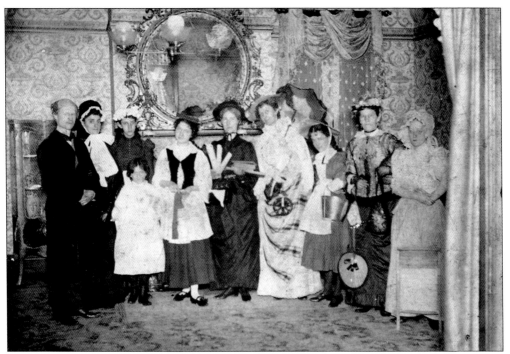
A cast of players from the Neville Island Church stands in the living room of the Pittock home, known as the Neville Island Mansion, in 1896.

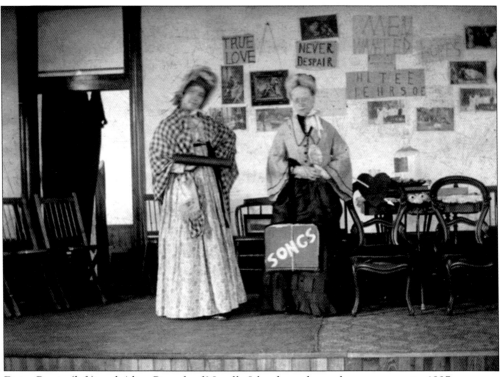
Daisy Petrie (left) and Alice Pittock of Neville Island are shown here on stage in 1897.

Two

MARKET BASKET OF PITTSBURGH

Due to its location along a low-lying flood plain of the Ohio River, Neville Island was ideally suited for farming. Thick stands of oak, maple, locust, and other indigenous trees that occupied the island in the late 1700s and early 1800s gave way to lush farms and gardens. Neville Island was known for many years as the "Gem of the Ohio" due to the fertile land. By 1880, there were more than 40 working farms on the island and a population of 306. Neville Island supplied some of the most celebrated produce in the United States. According to one account, the first strawberries ever marketed in Pittsburgh were grown on Neville Island, and the island's sweet corn was well-known in the Pittsburgh area. It was common for hotel owners and wholesale produce companies, such as H. J. Heinz, to contract in advance with farmers for produce grown the previous fall. Word of Neville Island's tasty produce reached large cities of the East Coast. New York City's Waldorf Astoria hotel featured "Asparagus a la Neville Island" on its menu in 1926. Even as late as the 1930s, farms continued to operate on Neville Island. Reports of cows from the island's farms floating by on the Ohio River were noted by residents following the 1936 flood.

Industrialization changed the island's farming identity starting in 1900, when the first industrial plants were erected. In 1918, the federal government's war department acquired 130 acres from farm owners for $8.7 million for construction of the nation's largest ordnance plant on Neville Island. It was dubbed the "floating factory." After the war ended, farmers fought fiercely to keep their land, but the land was put up for sale at a price much higher than they could afford. U.S. Steel Corporation outbid the farmers, some of whom owned their land for 100 years. Thus by 1921, the transformation of the great "Market Basket of Pittsburgh" into an industrial center was complete.

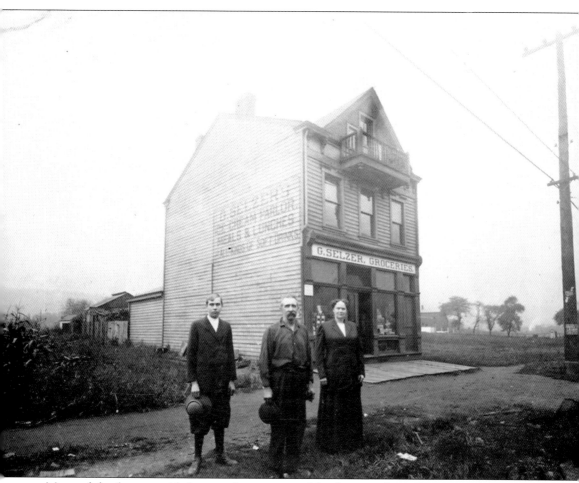
Many of the farmers sold their produce in stores like this one, located at Second Street and Grand Avenue on Neville Island, in the early 1900s.

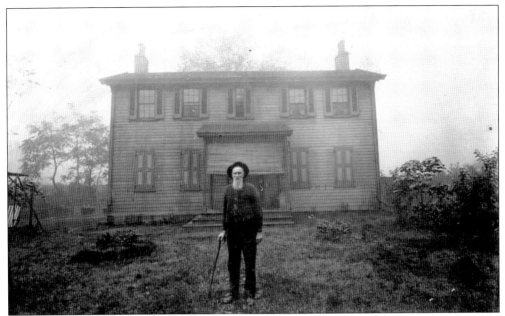

Taken in the early 1900s, this photograph depicts a time of fruitful and vast lots of land within a growing community. Jacob Warner stands in front of this home, demonstrating the days of peace and solitude between the people and the earth. This house once stood at the east end of the island.

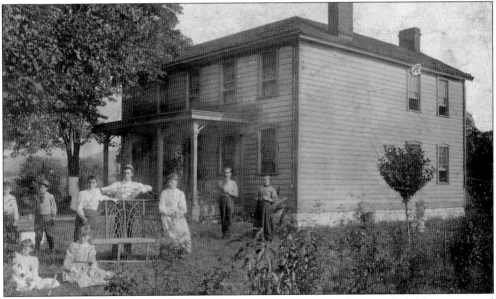

The farming families of Neville Island grew corn, asparagus, strawberries, rhubarb, grapes, and fruit trees in the island's fertile soil. Author Fortescue Cuming noted of Neville Island in the early 1800s, "It is narrow but its soil being of the finest quality, it might be divided into several good farms; there is however, but one on it, cultivated for the proprietor, Major Craig of Pittsburgh who has on the middle of the Island a large but very plain wooded farm house." Today residents report still finding wild rhubarb, asparagus, and strawberries growing. Some have found these located along the rivers edge, in back yards, and in between the cracks on concrete.

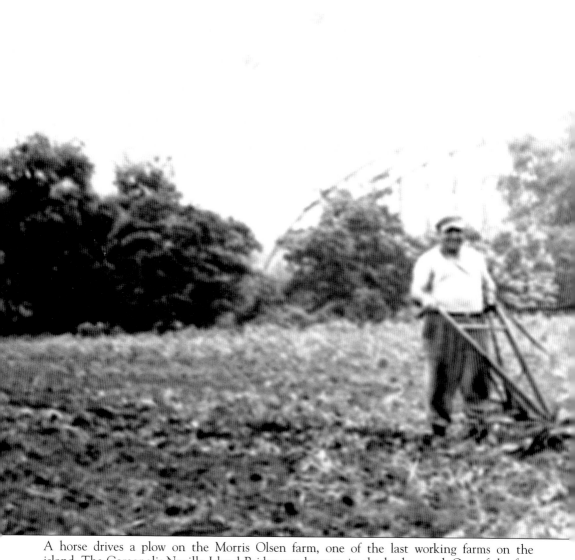

A horse drives a plow on the Morris Olsen farm, one of the last working farms on the island. The Coraopolis-Neville Island Bridge can be seen in the background. One of the first

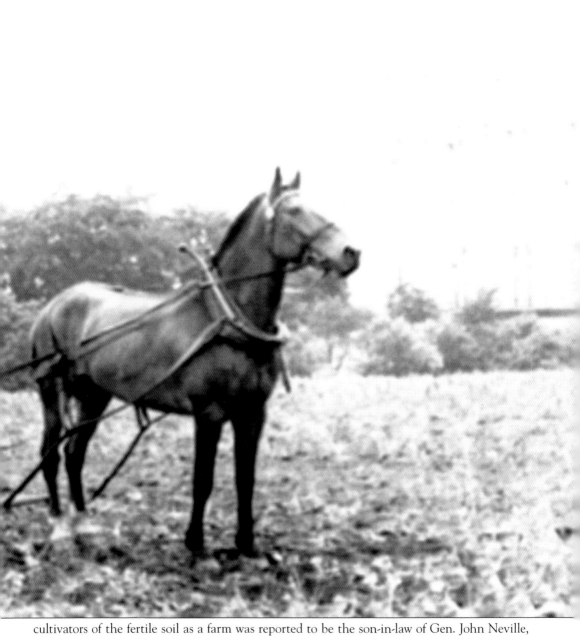
cultivators of the fertile soil as a farm was reported to be the son-in-law of Gen. John Neville, Capt. Isaac Craig.

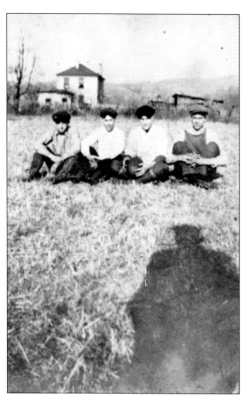

Four farm workers sit in their newly-plowed field on the island.

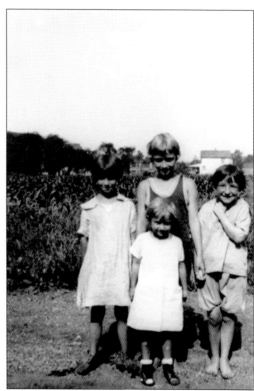

From left to right, Rose Weber Charlton, Margaret Weber Selzer, Hinney Moore, and Johanna Farrell stand in front of a Neville Island cornfield, now a football field.

This farm stood between Gibson Lane and the west side of Neville Island. This photograph depicts a rare view of farm life on the island.

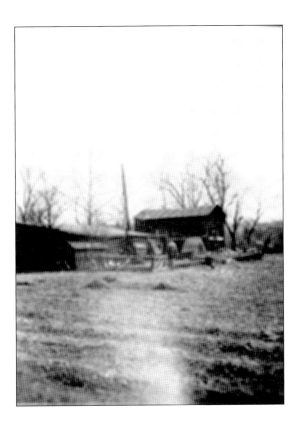

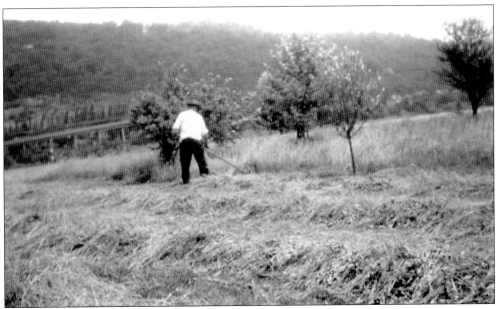

This man is cutting hay on the banks of the Ohio River in June 1939.

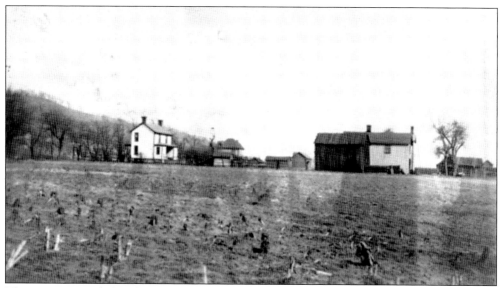
These are typical farmhouses with barns and cornfields waiting for spring planting on Neville Island.

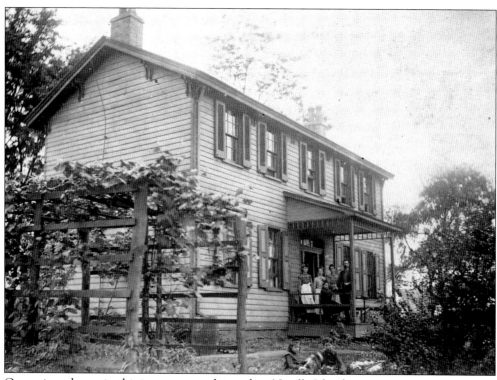
Grapevines shown in this image were cultivated on Neville Island.

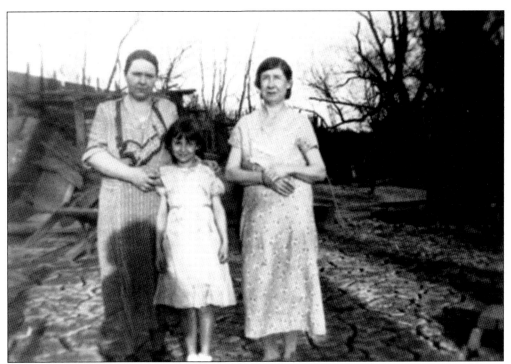

This photograph shows three women standing on a parched patch of land on the island.

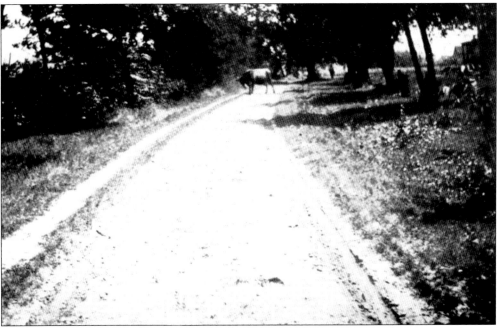

A cow stands on Neville Island's River Road in 1918, just before the federal government bought 130 acres from farmers for a never-constructed munitions plant. The island supported 40 working farms. The soil was rich with minerals and the land was extremely fertile. Produce readily grew and made for a prosperous living among residents for many years.

Jimmy Firestone stands in a farm field in front of the lock house, which was built in 1906.

Three

GOD'S SPIRIT

The story of the river continues prominently through the history of the church. In 1842, the community built a schoolhouse. However, congregation members wished to use the space as a church. The school gave the congregation members permission to worship and hold church services. It is unknown what happened to this original building. By 1848, the islands residents built the first church. In the early 1820s, church was held in the homes of the residents of the island. These services were usually at the Hamilton residence during the 1820s. In 1828, Mrs. David Hamilton, concerned with the lack of religious training for the children of the community, was the first to organize Sunday school from her log house home. An avid student of the Bible, she taught directly from it and instilled in the hearts of children a love of God and respect for His word. This establishment was a milestone for the progress and growth of the religious life of the community.

Decades later, this influence could still be felt at Neville's school graduation ceremony. During graduation ceremonies, it was common to begin with an evening prayer, sing spiritual hymns, listen to the reverend give a sermon, and then close in prayer and a scripture reading from the Bible. Each year, different readings from the Bible were read from chapters such as the book of Psalms, Luke, and Matthew. For the commencement ceremony of 1939, Revelation 21:1–8 was read and repeated again for the graduating class of 1942, and this time, Revelation 22:1–5 was added. These scriptures speak of a new heaven and earth and describe God as being the alpha and omega, beginning and end. It continues to describe a city by the river and its tree of life. This reading demonstrates the future and hope of a community being spoken through the scriptures.

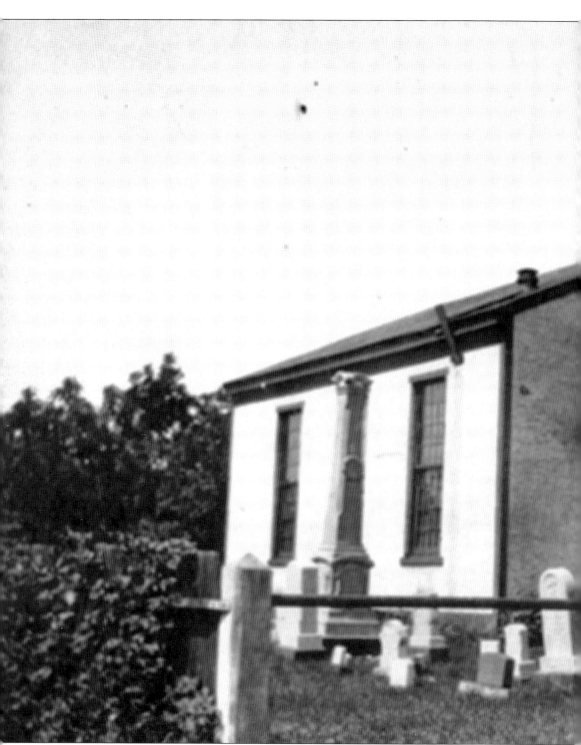

Organized as a congregation on May 6, 1843, this church was originally built as a schoolhouse in 1842. As a growing community of Christians emerged, a space for people to gather together and worship was sought. In 1843, the school gave permission for it to be shared as a church. It is

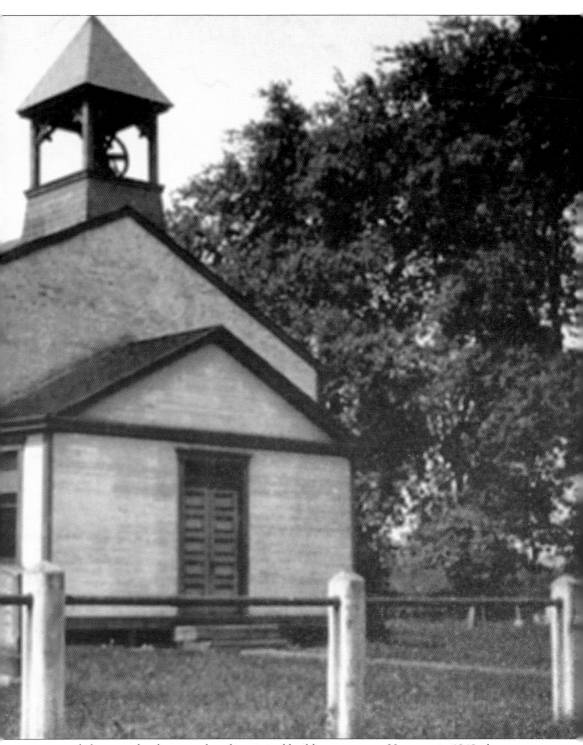
not exactly known what happened to the original building structure. However, in 1848, the new, redbrick building, now considered the island's first church, was built in its place. This church stood at the site where the current and well-hidden Long Island Cemetery stands today.

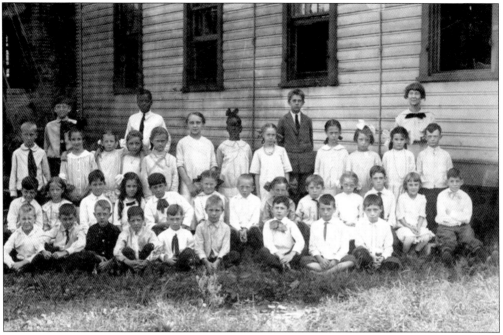

These young children are posing for a class picture in 1913. Notice the small boy in the left front row wearing black. During this era, it was an uncommon color to wear unless the individual or family was in morning.

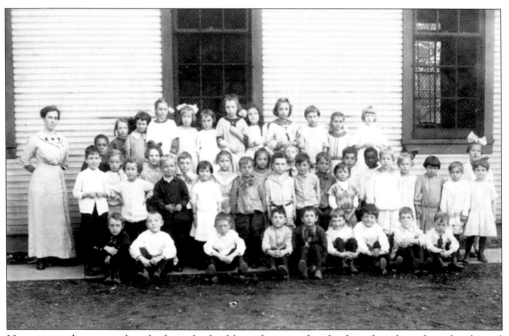

Here is another rare, close look at the building that acted as both a church and a school until the first official school was built in 1915. This photograph includes all the students attending the school not just a particular grade. Before the new school was built, students shared classrooms together.

In the Christian faith, First Holy Communion is generally first received by a person as a child. In this photograph, James Martin appears to be about the age of eight.

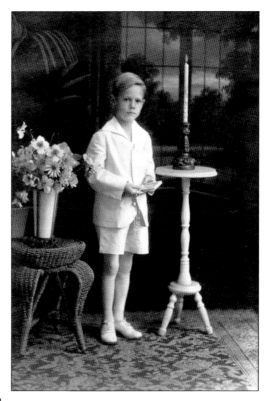

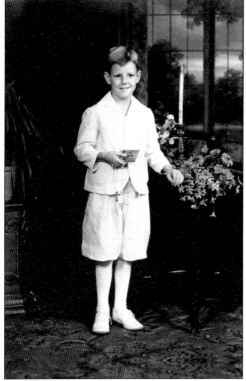

Often when children receive the sacrament of holy communion, they are given gifts of Bibles and rosaries, as depicted in this photograph of John Martin.

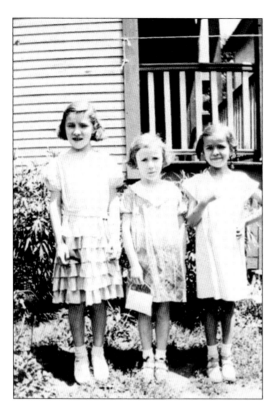

These young ladies are dressed in their Sunday best. It was common for girls during this era to carry a small white purse to church that contained, in most cases, a small bible, white gloves, and a handkerchief.

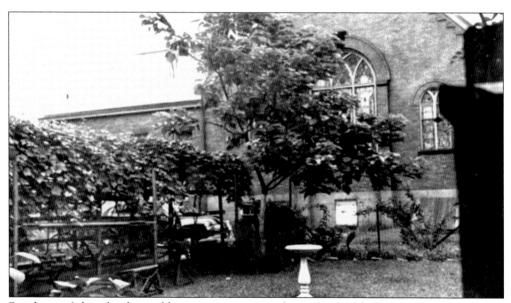

Residents of the island, in addition to growing produce, also had lush grape vines and made their own wine. This is the backyard of the Pentland residence, where the now-standing Neville Island Presbyterian Church can be seen.

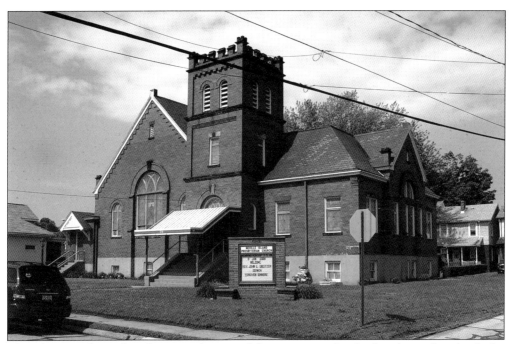

This photograph catches the magnificence of the current and only church on the island, the Neville Island Presbyterian Church. Built in 1917 at a cost of $20,000, this church was built in a Romanesque style with arched, stained-glass windows. It is located on First Street.

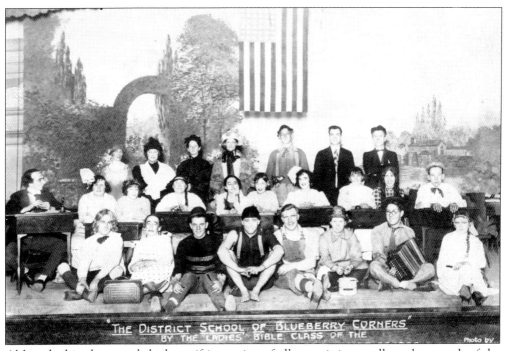

Although this photograph looks as if it consists of all men, it is actually a photograph of the Neville Island Presbyterian Church ladies Bible class dressed for the performance of *The District School of Blueberry Corners*.

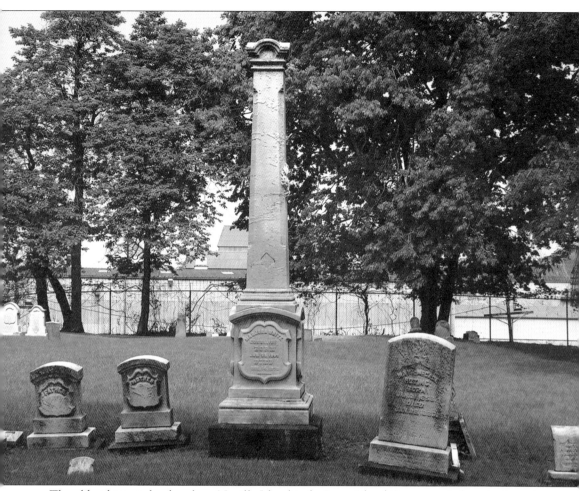

The oldest historic landmark on Neville Island is the Long Island Cemetery. It dates back to the mid-1800s and consists of about 100 graves. It is virtually inaccessible, and one can only get in by obtaining both permission and a key that is located in the town's municipal building. Located in the cemetery is the resting place of the settlers of Neville Island, who were buried there when it was surrounded by the fertile soil of the farmlands. Today it is surrounded by the local industries, but it is protected and not in jeopardy of being torn down. Residents consider it a testimony to legacy of the island's forefathers and founders.

Four

EDUCATION

The children belonging to the early settlers of Neville Island were generally educated at home. The first schoolhouse was not built until 1842 and was also shared with the church community. However, before this schoolhouse was built, a woman by the name of Harriet Craig Fleeson taught various subjects to young islanders from her kitchen. After sharing with the island's congregation members for several decades, residents decided to build a new school building to better meet the needs of a growing school and church community. In 1915, Neville Island School was built and opened.

The school deeply emphasized that all students do the best they can. In 1933, one account of this took place in the life of James W. Giacobine Jr., M.D. When Giacobine was a six-year-old little boy, he had to have a hernia operation. Impressed by the stunning presence of his doctor, Giacobine decided he wanted to become a doctor someday. However, he was not a motivated student. He began his high school years with very poor grades. His homeroom teacher, Marie Watters, took an interest in Giacobine and convinced him he could achieve good grades and pursue his dream of becoming a doctor. Within a year, Giacobine went from being at the bottom of his class to the top of the class. Watters remained with Neville Island School for many years. She was known and respected for investing in the lives of her students and the community.

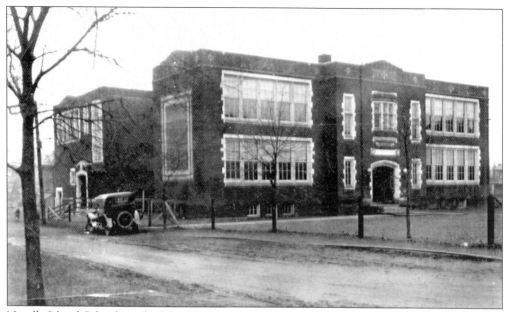
Neville Island School was built in 1915.

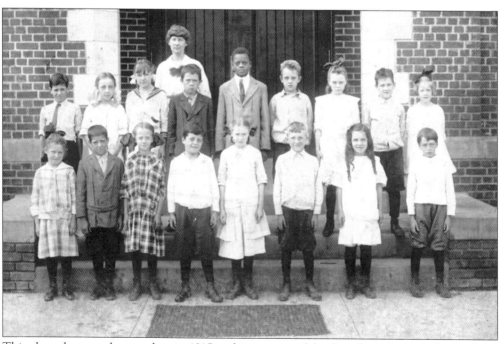
This class photograph was taken in 1915 and it was one of the first class pictures taken in front of the new school.

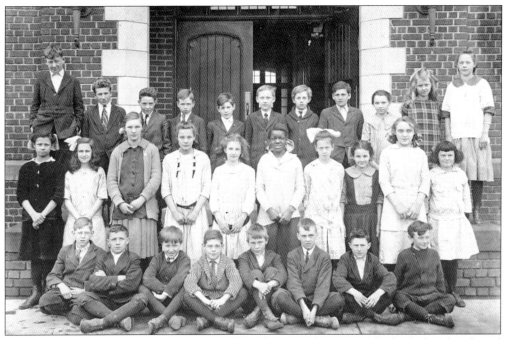

The growing community could no longer share the space being used for both the church and the school. Within two years after the Neville Island School was built, a new church was built as well, and both the congregation and class size quickly increased.

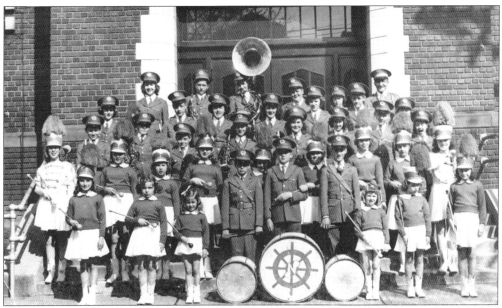

Photographed here is the Neville Island School band at its height. Equipped with a diverse array of entertainment, the school band proudly displays the letter *n* on the drum base. The children stand obediently in complete uniform, reflecting an established community.

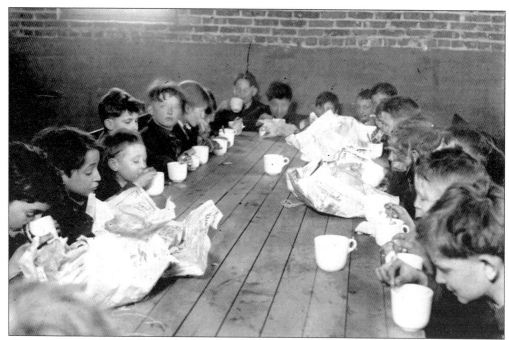

Students at Neville Island School ate lunch in the basement of the building. In this photograph, students were given tomato soup, which was served and introduced by women from State College. The idea was to complement the already-packed sandwich and pie that the students brought with them as their regular lunch in order to have something warm and enjoyable during the cold of the winter.

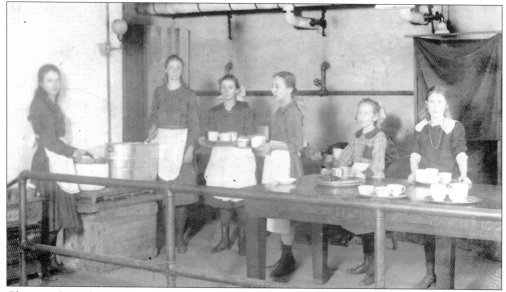

Clean up from the soup lunch was done by using two wash tubs. One tub consisted of soap and water, and the other had plain water for rinsing. All dishes from the students were washed in these tubs. Elizabeth Lackey was the principal of Neville Island School during this time and supervised the older girls of the school who helped with the lunch. Seventy children enjoyed this soup for 3¢ per child.

Seen here is the class of 1943 as freshman.

This is a report card from 1926 that belonged to a 10 year old. Students at this time were not only graded on subjects such as reading and writing but also behaviors. Seen here are behaviors students were graded on, such as attitude, effort, and hygiene.

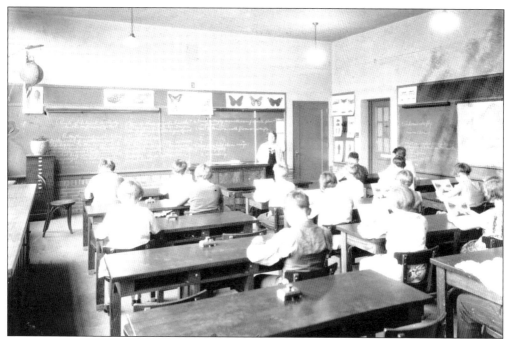

Captured in this photograph are students learning science. They are learning about insect species such as butterflies while also examining charts and graphs. Teachers frequently arrived very early to write entire lessons on the chalkboard.

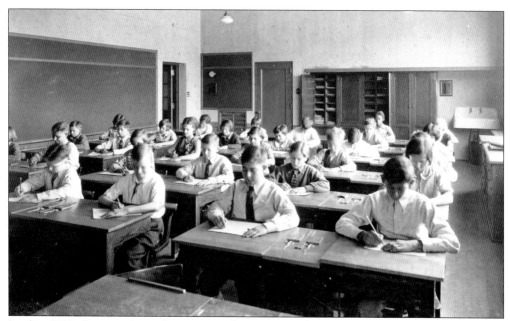

In this 1930 photograph, students are studying art. Each student was provided with scissors, drawing pencils, and crayons. This photograph was taken in the new junior high school addition. On January 28, 1933, Dr. Charles E. Dickey, superintendent of Neville Island School, received a letter of approval from the department of public education to extend program studies to include 10th grade.

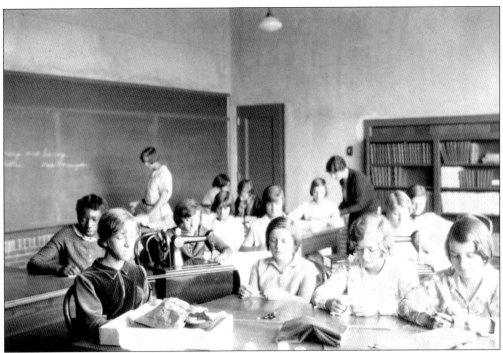

In this sewing class, students used foot-petal sewing machines. Boys were required to take sewing along with girls.

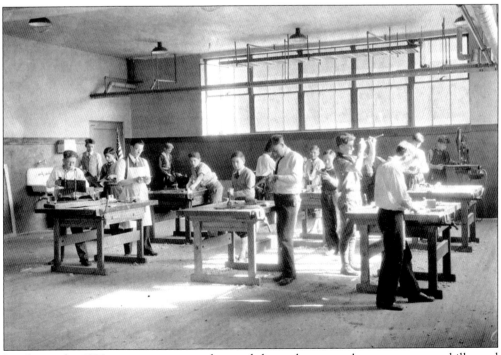

In the early 1930s, young men took wood-shop classes to learn carpentry skills and develop precision.

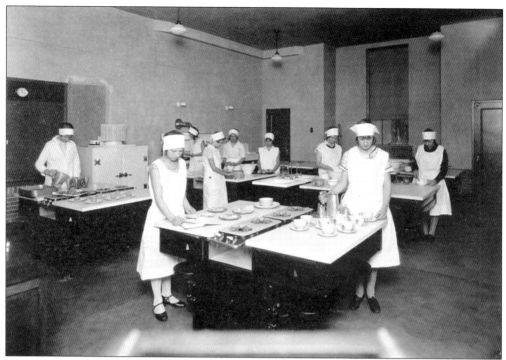
Etiquette was taught to young women, and they were expected to learn how to serve guests.

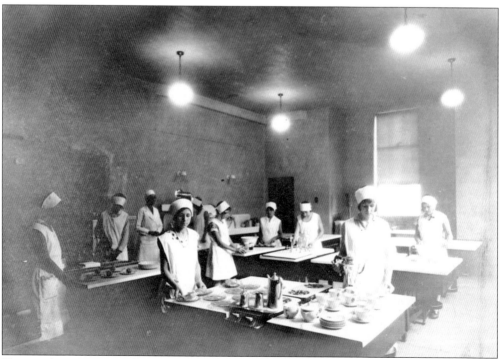
Elegant place settings and serving tea were taught to young ladies in home economics class.

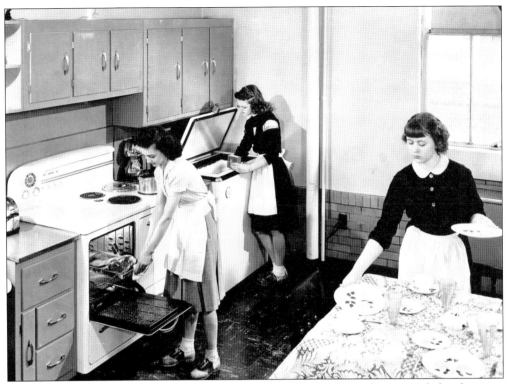
Home economics courses were only open to girls. Seen here are the young ladies learning cooking, baking, laundry washing, and table-setting skills.

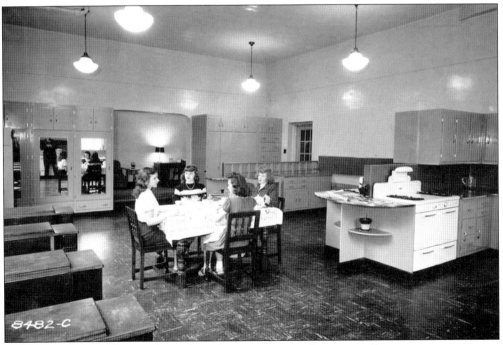
Table manners were frequently taught in home economic classes as well.

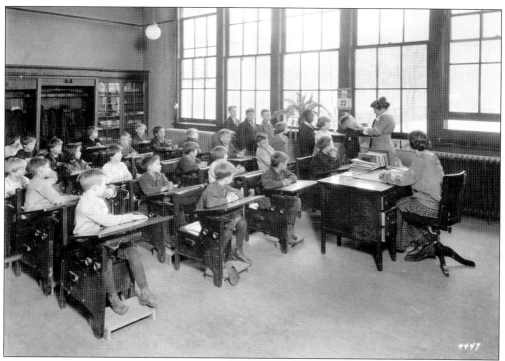

In the winter of 1915, the students were examined by the nurse, Ms. Mong. She measured their height and weight.

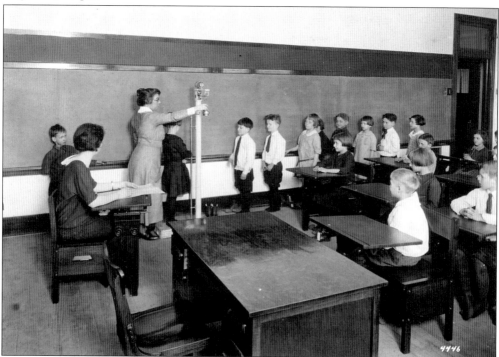

Health checks continued yearly among the students, as part of a required health evaluation. As the nurse examined the students, teachers recorded the student's information.

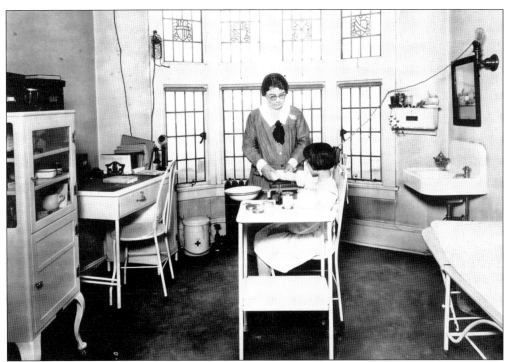

A small child is getting bandaged by Mong. The bowl below the child's arm was used for cleansing wounds. Medicine and beds were also available for sick children.

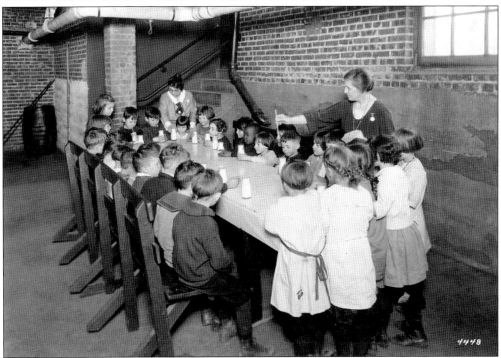

The basement area of the school was used as the lunchroom for many years. Here Mong is also helping to serve lunch with first grade teacher Miss Armstrong.

Girls frequently made their own prom dresses, as they were skilled in sewing. Students decorated the 42-foot-long gym and seven-and-a-half-foot tall walls to create a thematic ambiance for their prom night. In the case of these students, they chose New England as their theme.

Neville Island High School was dedicated on March 18, 1959. Students welcomed rival teams and competition.

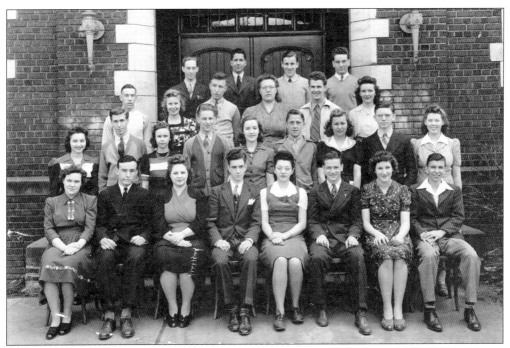

Seen here is the class of 1942. By 1972, Neville Island and Coraopolis merged school districts into one large, new building and renamed the school Cornell by combining the names of Coraopolis and Neville Island.

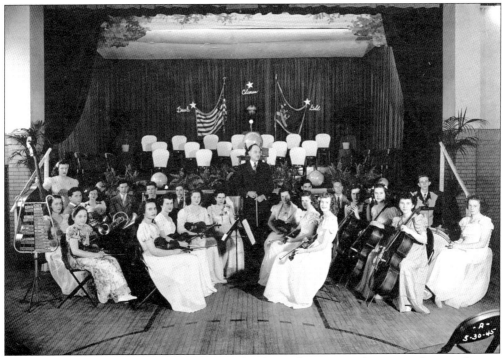

The school band performed concerts in the school gym during special events such as graduation and Christmas concerts. Students were expected to dress formally by wearing suits and gowns.

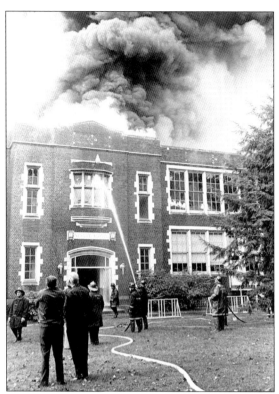

Seen here in 1972 is Neville Island School under a cloud of heavy smoke and engulfed in flames. The cause of the fire is still unknown.

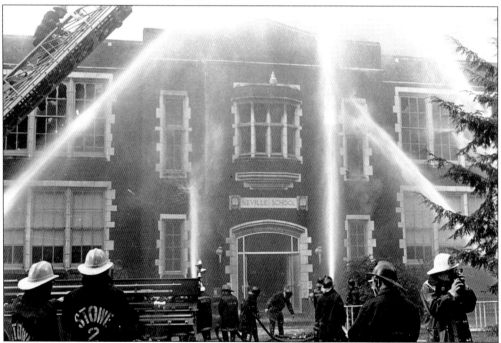

Water streams from five fire hoses can be observed as firefighters desperately try to combat the fire. A firefighter is seen at the top of the fire ladder. Only the first floor of the school was salvageable and is currently occupied by offices.

Five

ISLAND INDUSTRY

The island's largest land-use transformation occurred in 1918, when the federal government's war department announced that the nation's largest ordnance plant, operated by U.S. Steel Corporation, was to be constructed on Neville Island at a cost of $50 million. The *New York Times* declared on May 4, 1918, that the "plant will be the largest in the world, even surpassing that of the Krupps in Germany." But just as quickly as it was announced, World War I ended, and construction of the ordnance plant was abandoned. Residents who tried to reacquire their land were outbid by U.S. Steel. By 1921, the transformation of the great "Market Basket of Pittsburgh" into an island of industry was complete.

By 1938, almost all the eastern end of the island had been industrialized. One of Neville Island's most famous industries was the Dravo Corporation, a ship building and infrastructure construction company founded in 1891 by Francis R. Dravo (1866–1934) and Ralph Marshall Dravo (1868–1934) and moved to Neville Island in 1901. The company's patriarch, Antoine Drevou of France, born in 1769, lived in Pittsburgh and died in Lawrenceville in 1851. The company began building ships in 1915 and launched more than 6,000 hulls. By 1958, Dravo operated the largest inland boat works in the United States, in addition to constructing dams, bridge supports, and other infrastructure. In recent years, other companies such as FedEx Ground/ Roadway Package System (RPS), New Penn Motor Express, West Rentals, Verichem, Pittsburgh Gear, Tri-State Trailer, Overseas Packaging, and Calgon Carbon Corporation research lab have constructed new or modernized facilities that have started to improve the image of Neville Island.

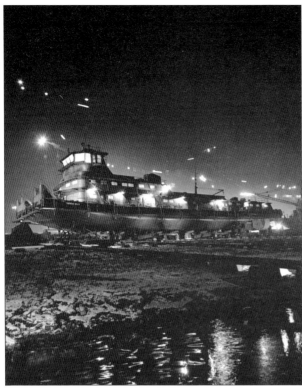

The Dravo Corporation's engineering works division at Neville Island operated one of the largest inland waterway shipyards in the United States. Founded in 1891 by Francis R. Dravo (1866–1934), the Dravo Corporation began by constructing flat-bottomed barges and paddle-wheel boats for use in the shallow waters of the Ohio, Monongahela, and Mississippi Rivers that carried the coal, iron ore, and other materials from Pittsburgh factories. (Courtesy of Library and Archives Division, Sen. John Heinz History Center.)

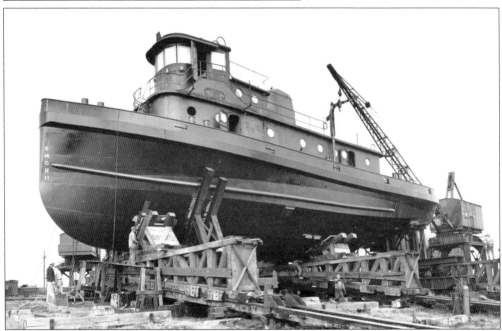

The Dravo Corporation has launched more than 6,000 hulls since it entered the shipbuilding business in 1915. This location also included a side-haul marine repair facility. Some of the ships manufactured at this facility include hopper, tank, and deck barges, towboats, tugs (pictured), dredges, and special-purpose vessels.

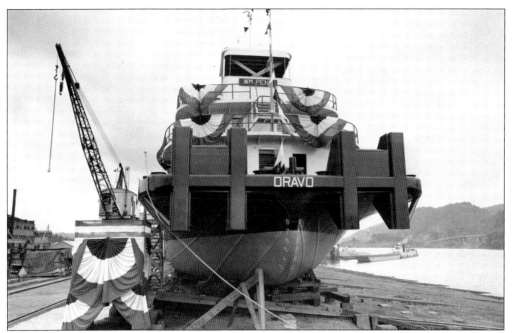

This photograph shows the river barge *Wm. Penn*, built for the Union Barge Line Corporation just prior to launch in June 1940. In 1929, the Dravo Corporation purchased an interest in Union Barge Lines. By the late 1950s, Union Barge Lines owned and operated 10 diesel towboats, such as the one seen in this photograph, and more than 300 barges.

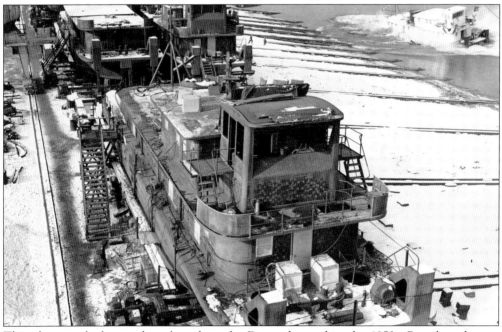

This photograph shows a boat launch at the Dravo shipyard in the 1950s. Boat launches on inland waterways like the Ohio River were performed with the ship entering the water broadside. Dravo ended ship-building in the 1980s and began to design machinery for the mining and chemical industries.

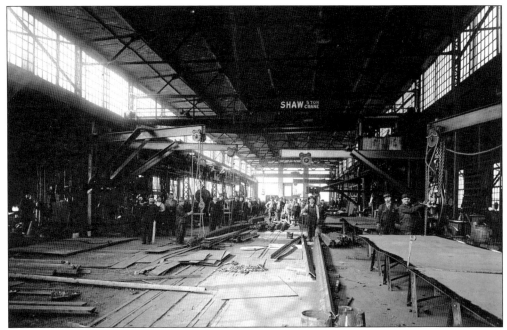

During World War II, the Dravo Corporation was a leader in the construction of Landing Ship Tank (LST) craft that were used in the European and Pacific campaigns. LSTs were enormous ships that could carry more than 20 tanks along with 160 soldiers and deliver them directly to a beach landing site. Dravo's workers produced a total of 145 LSTs.

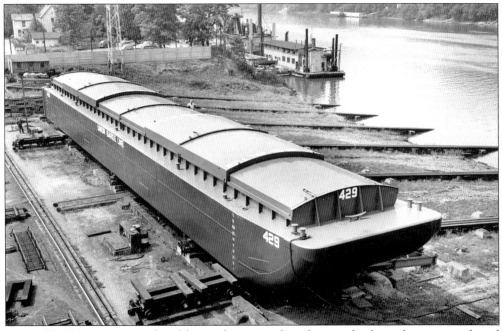

Vessels like these were critical workhorses for moving large barges of industrial raw materials and finished products along Pittsburgh waterways. By the 1950s, Dravo-built barges carried nearly 55 million tons. After the war, Dravo used scrapped warships for building bridges, dams, and other infrastructure across the United States.

Neville Island's Pittsburgh Screw and Bolt Corporation became Dravo Light Metals.

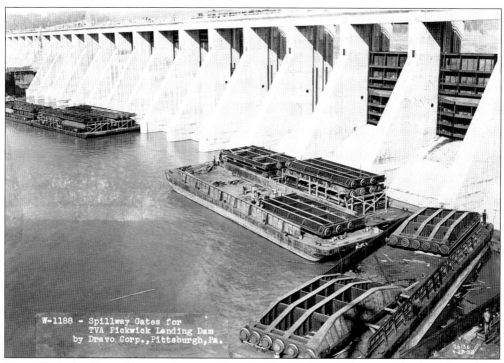
Since 1902, the Dravo Corporation was also a leading builder of dams and bridges throughout the mid-Atlantic region. Dravo was also responsible for the construction of Gallipolis Dam (now Robert C. Byrd Dam) on the Ohio River, which was the largest roller-gate dam in the world when completed in 1938. The Dravo Corporation was involved in 47 major bridge construction projects between 1903 and 1947.

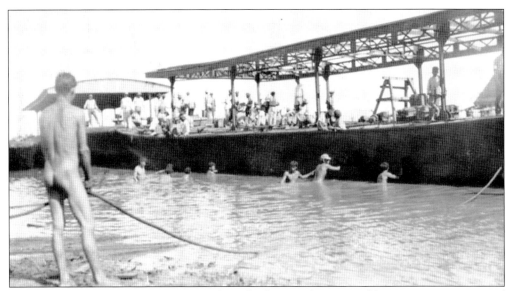

With many white workers fighting for the Allied cause during World War I, immigrants and African Americans came to Pittsburgh to work in mills and factories, including building ships on Neville Island.

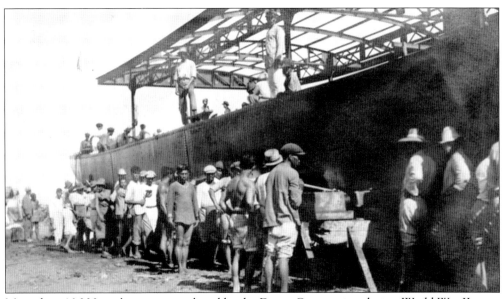

More than 16,000 workers were employed by the Dravo Corporation during World War II.

This is a boat-christening party on Neville Island on June 18, 1926. It was customary for the builders to celebrate a ship launching. The entire community was part of the festivities.

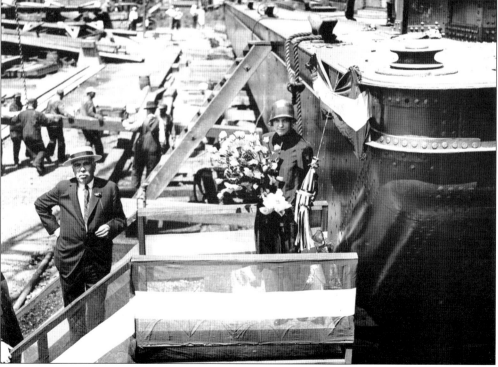
A Neville Island community dignitary is about to christen a Dravo-built barge on June 18, 1926.

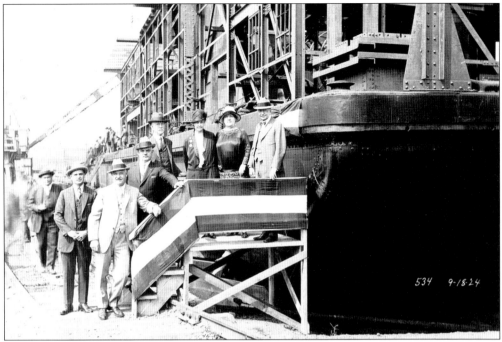

This shows a boat-christening ceremony on September 18, 1924. Boat-christening ceremonies ensure good luck for the ship and its crew. It is believed that if a boat does encounter bad luck, it is due to an improperly performed christening ceremony.

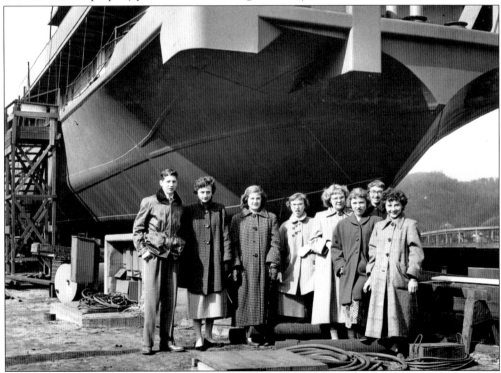

Neville Island High School seniors during "office practice" visit a ship about to launch in 1952.

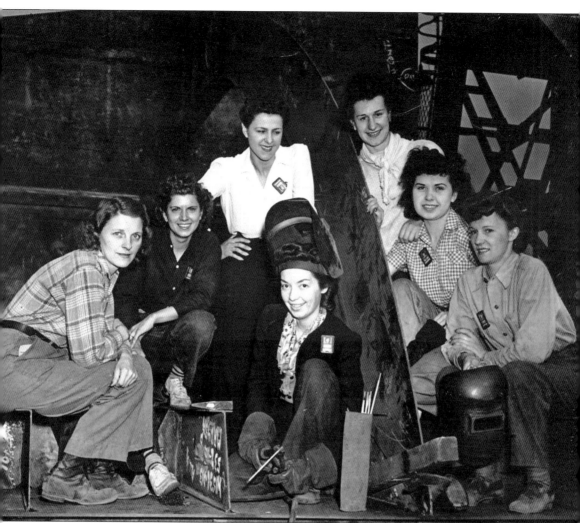

The first women welders on Neville Island are shown in this 1942 photograph. During World War II, Rosie the Riveter was an image promoted by the federal government to encourage women to work for the war effort. At the outbreak of war, 12 million women were already working, and by the end of the war, the number increased to 18 million, with three million women working in factories.

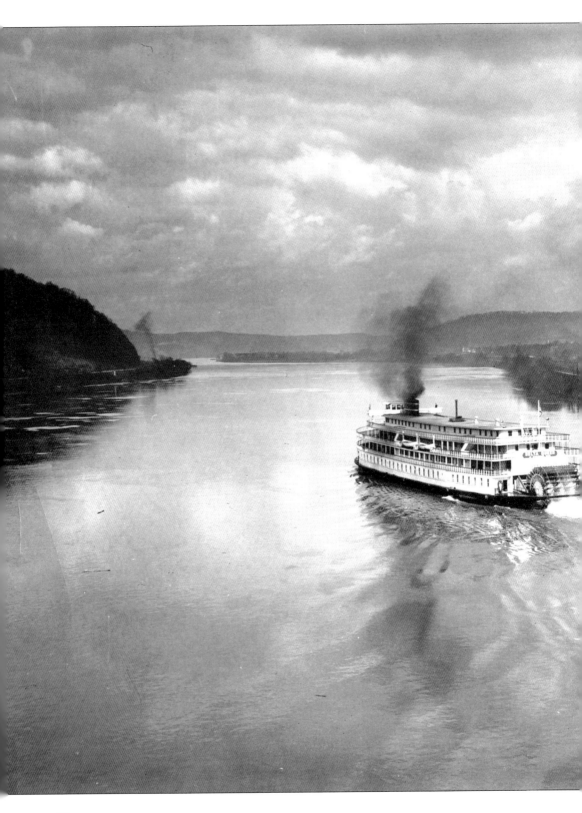

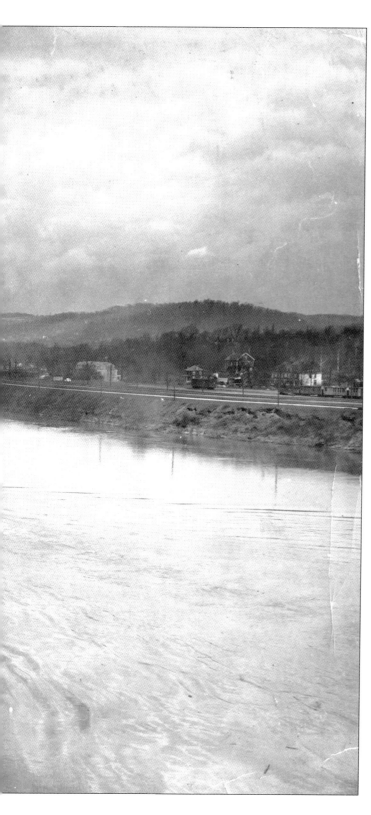

The *Delta Queen* is seen here plying the Ohio River near Pittsburgh. Built in 1926 in Stockton, California, the *Delta Queen* originally served the Sacramento River between San Francisco and Sacramento. The *Delta Queen* was restored on Neville Island by the Dravo Corporation in 1946. The *Delta Queen* is listed on the National Register of Historic Places and was declared a national historic landmark in 1989.

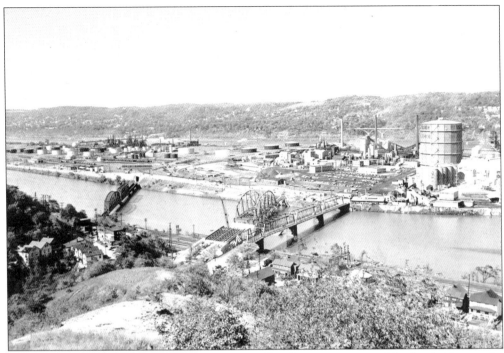

Industrialization of Neville Island was precipitated by the construction of the first bridges to the island in 1892. This is a photograph of the old and new Fleming Bridges, sitting side-by-side on September 26, 1954. Prior to bridge connections, Neville Island residents commuted with the mainland by boat.

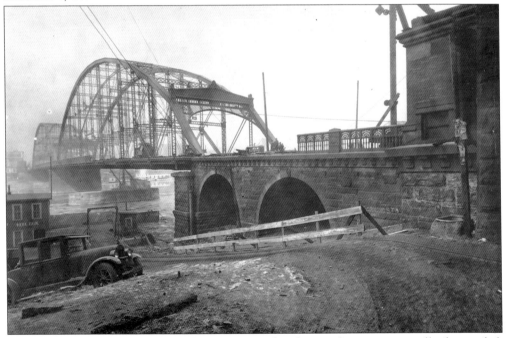

The old Sixth Street bridge from downtown Pittsburgh, seen here, was partially dismantled, floated downstream on pontoons, and reerected on the western end of the island in 1927.

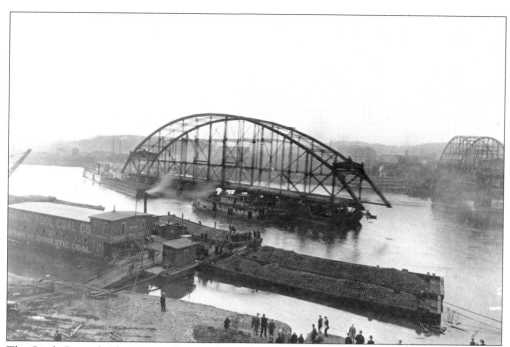
The Sixth Street bridge is seen floating down the river toward Neville Island on May 4, 1927.

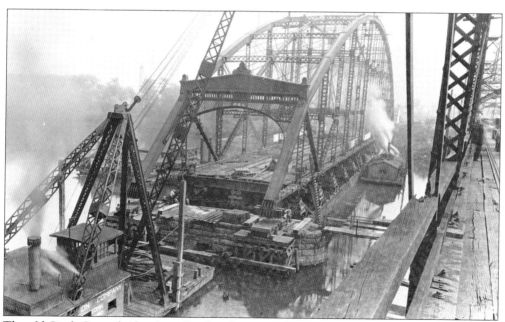
The old Sixth Street bridge from Pittsburgh is moved into place on July 25, 1927, to connect Coraopolis with Neville Island.

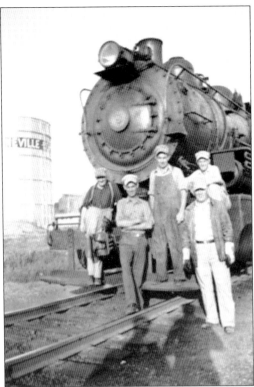

This photograph shows the engine crew of the Pittsburgh and Ohio Valley Railroad at the Pittsburgh Coke and Chemical Company in the 1940s. Industrial work often galvanized relationships among coworkers.

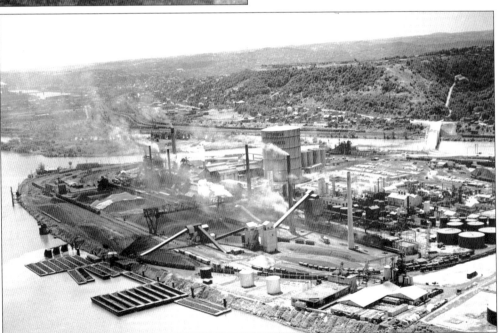

This is a 1952 aerial view of the Pittsburgh Coke and Chemical Company, which provided products for Pittsburgh's steel industry. The plant occupied the eastern tip of Neville Island on land originally occupied by the American Steel and Wire Company. It is now called Calgon Carbon Corporation. (Courtesy of Library and Archives Division, Sen. John Heinz History Center.)

Six

A River Story

The history of Neville Island is, in large part, a river story. From its earliest days of human habitation, the Ohio River played a key role in Neville Island's history. It served as a source of transportation, irrigation, recreation, and fear from floods. Until bridges were built connecting Neville Island to the mainland, produce and supplies were transported by boat. Prior to dam construction, some residents reported the ability to walk across the back channel of the Ohio River to Coraopolis during low tide in summer. The island also supported a beach. Long-term Neville Island residents Henry and Ruth Hartz reported in 1919, "The rivers were low at that time, and you had a sandy beach all along the river. All the way around the Island was just a sandy beach. It must have been 20 foot long, anyway, to the water."

Floods were a pressing concern as Neville Island's community grew in the 20th century. Four major floods affected Neville Island: 1907, 1936, 1937, and 1972. The worst was in 1936, which devastated properties. Dams built on the Ohio River included the Davis Island Lock and Dam (1886) and the Emsworth Locks and Dams (1922), which replaced it. Both dams were attempts to control flooding along the Ohio River valley. The Davis Island Lock and Dam was the first lock and dam built on the Ohio River. At the time, it was the world's largest movable dam. Today the Ohio River continues to be a resource for industry, transportation, and recreation. Many homes built along the riverfront take advantage of the placid lifestyle of a river with an immense history.

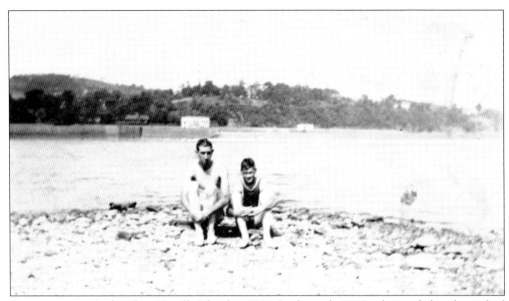
Two men enjoy the beach at Neville Island in 1928. In the early 1900s, the sandy beach reached out to the rivers edge, providing much room for enjoyment.

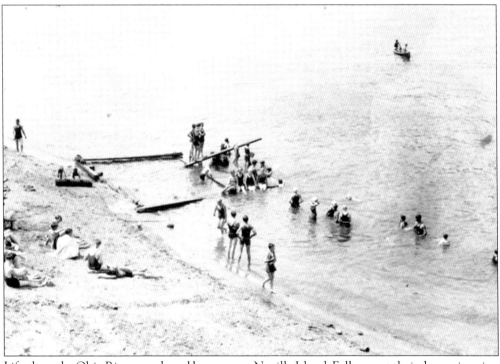
Life along the Ohio River was shared by many on Neville Island. Folks spent their days swimming at the edge of the river.

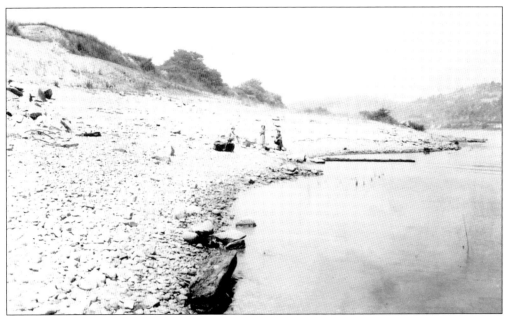

Despite its modern industrial reputation, the Ohio River provided a much-needed respite for Neville Island residents in the early 1900s.

Two girls and their dog are seen wading in the Ohio River at Neville Island in the early 1900s. Personal testimony of residents speaks of people being baptized in the river.

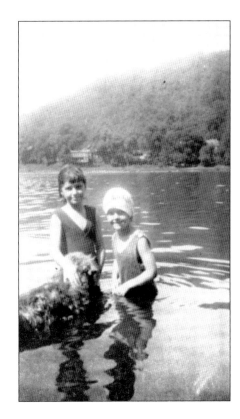

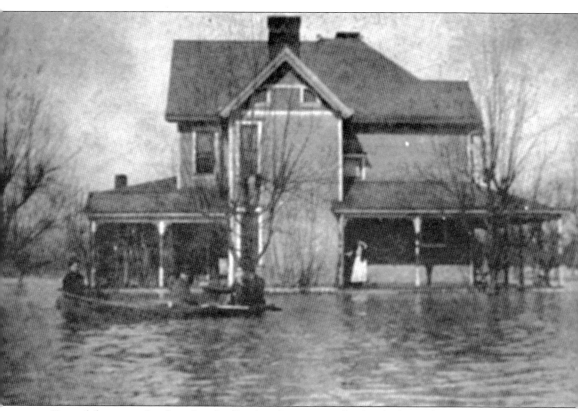

One of the worst floods to hit the Pittsburgh area was the flood of March 14, 1907. The water rose to 34 feet in downtown Pittsburgh. The flood affected 2.5 million people and cost the region more than $9.3 million in damages. Here, a house sits flooded on Neville Island, with a rowboat paddling by.

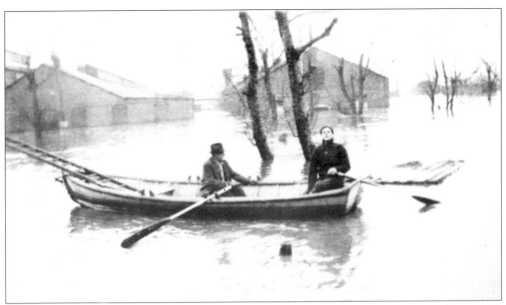

The worst flood to hit the Pittsburgh region was the St. Patrick's Day flood of March 17, 1936. Floodwaters peaked at 46 feet and devastated much of the area. More than 100,000 buildings were destroyed, and it cost the region more than $250 million in damages. At its highest point of 50 feet, Neville Island was almost completely covered in water.

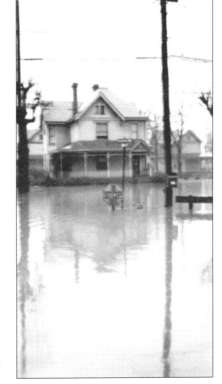

The Pittsburgh region barely had a chance to recover from the 1936 flood when another flood hit in January 1937. Known as the Ohio River flood of 1937, it affected properties and people from Pittsburgh to Cairo, Illinois. The damage left one million people homeless, 385 dead, and cost $500 million in losses at the height of the Great Depression. In this photograph, a stop sign on Neville Island is submerged.

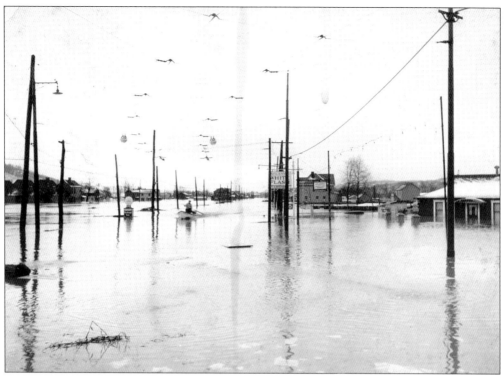
A rescue rowboat on Neville Island takes residents to safety during the 1936 flood.

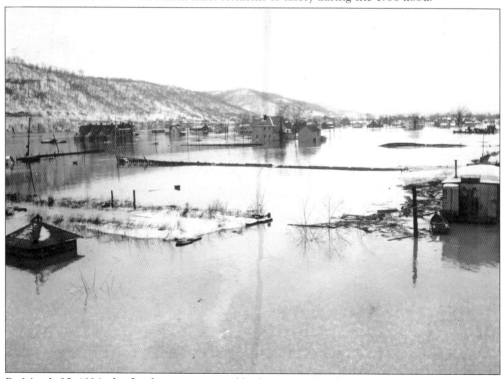
By March 25, 1936, the floodwaters remained high on Neville Island.

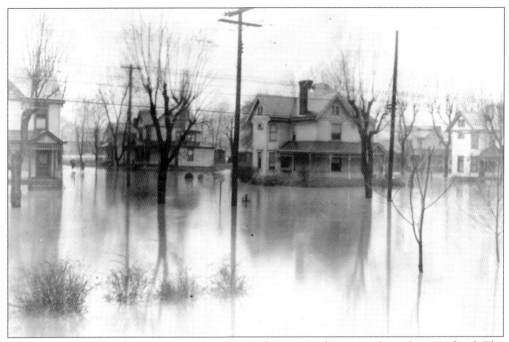

The extent of the flooding on Grand Avenue can be seen in this image from the 1936 flood. The homes are now gone, replaced by the Interstate 79 bridge.

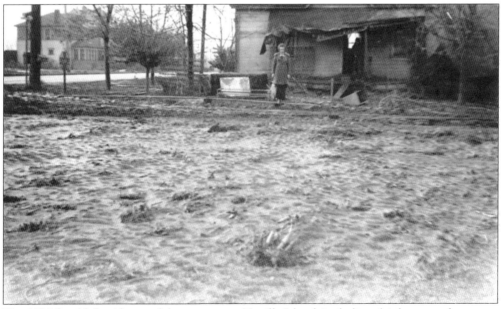

The 1936 flood left widespread damage across Neville Island, including this house at the corner of Grand and Cottage Avenues.

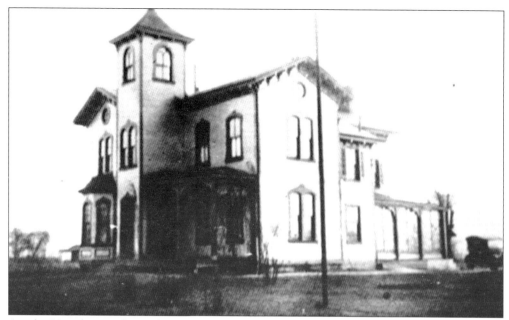

Amelia Hamilton, a descendant of Gen. John Neville, lived at this house on River Road on Neville Island, seen here in 1932. Her mother pioneered religious education for children on the island.

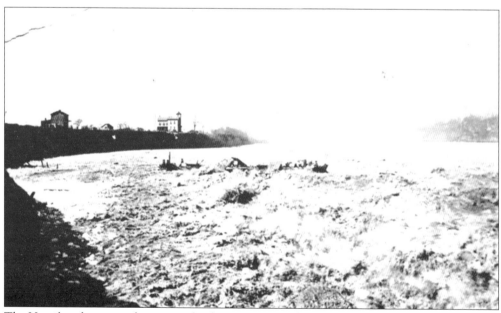

The Hamilton house can be seen in the distance on March 5, 1936, during the rising floodwaters, which rose from 21 feet to 42 feet in one week with little warning.

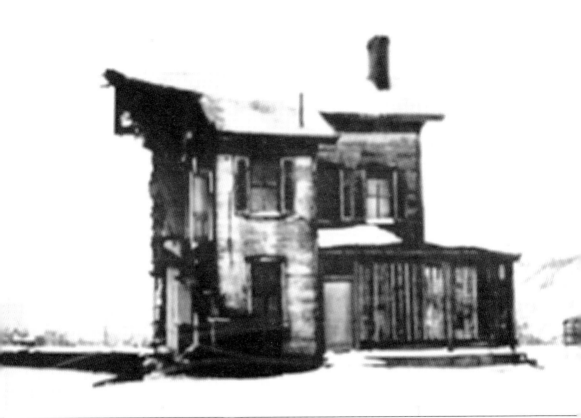
Half of the Hamilton house was swept away by the flood. It was later demolished.

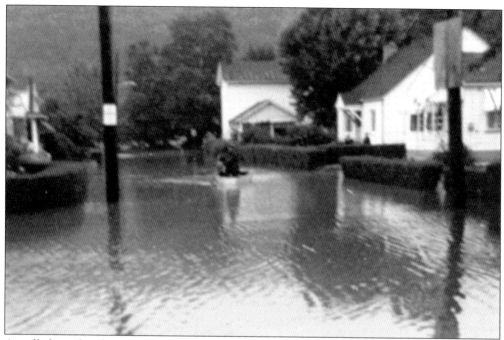

A stalled weather front over Pittsburgh following Hurricane Agnes hit Pittsburgh in June 1972 and floodwaters again devastated Neville Island. A person in a canoe is seen paddling through the flooded streets of the island.

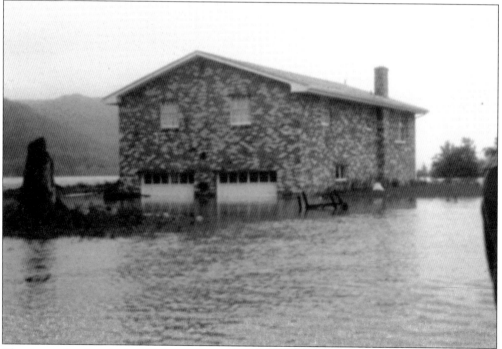

The Agnes flood peaked at 35 feet on June 24, 1972. Properties along the Ohio River, including one seen here on Neville Island, sustained damages of approximately $1 billion. Seen here is Front River Road.

Seven
Neville Island Sports and Recreation

Neville Island had more than just farms and industry. The island supported a number of sports teams and recreation facilities. As the population of the island grew and industrial work increased, sports and recreation were important outlets and a way for residents to have fun without traveling far.

Neville Island supported a number of sports teams, including baseball, basketball, and football clubs. Clubs for kids included a Girl Scout troop and the Neville Island Key Club. Neville Island also featured a number of indoor attractions. One of the most popular of these was Corpen Lanes, a bowling alley, as well as Corpen bar and restaurant that also featured outdoor dining. It was particularly popular among students, but people of all ages took part in the bowling and social activities. The Neville Roller Drome roller-skating rink was another popular attraction. Founded in 1948, it still provides a live organist who supplies entertainment to the roller skaters. It is considered to be the "best kept secret in Allegheny County," according to one of the co-owners, Dan Deramo. It featured a unique, floating floor for skating, the only one of its kind. The Deramos' pet dog Ringo was also a favorite of the visitors.

People traveled from all around the surrounding area to participate in these attractions. Many kids wished to celebrate their birthday parties by going bowling or to the roller rink. Teenagers went just to hang out, and it was also a place to go on a date. In 1975, the island also added tennis courts and purchased benches and slides for the playground.

Corpen was a popular bar, restaurant, and bowling alley for Neville Island residents. It is now called Paradise Island Bowl and Beach.

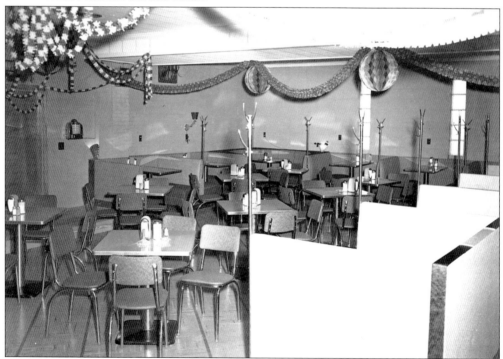

The inside of Corpen included a casual dining restaurant and a jukebox. Parties were frequently held here.

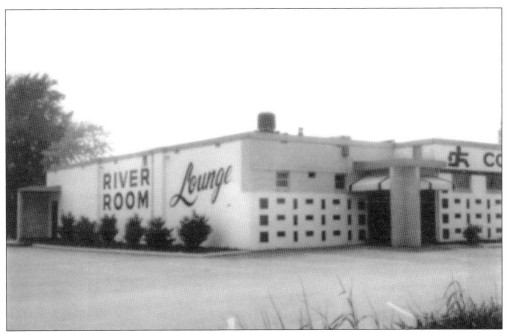

The bowling alley featured the River Room Lounge, a separate pub where people watched the bowling action. Since this photograph was taken, the lounge is now featured as a sandy beach above the river, called Paradise Island. Today the bowling lanes inside have been completely remodeled and are very innovative.

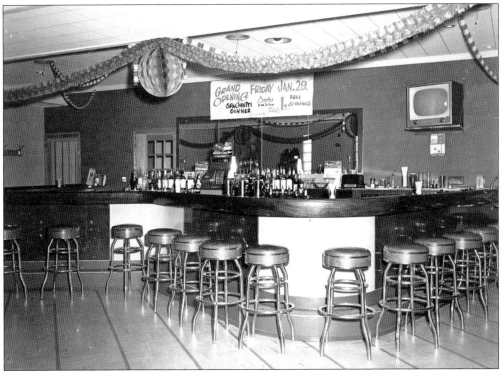

The wooden bar at Corpen was a unique S shape.

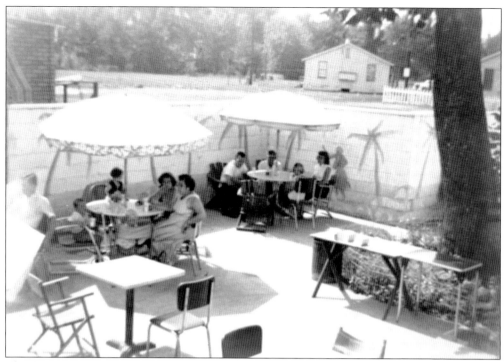
The Corpen Lounge featured outdoor dining. Many families went there for a night out.

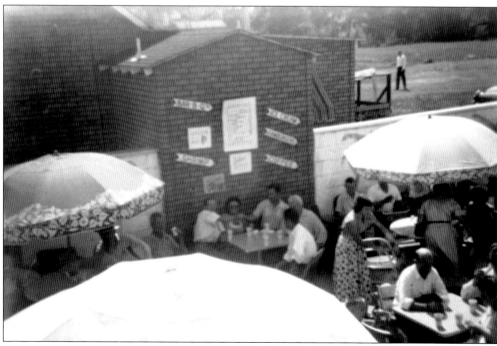
On a warm summer day on Neville Island, there was no better place to be than the outdoor deck at the Corpen Lounge.

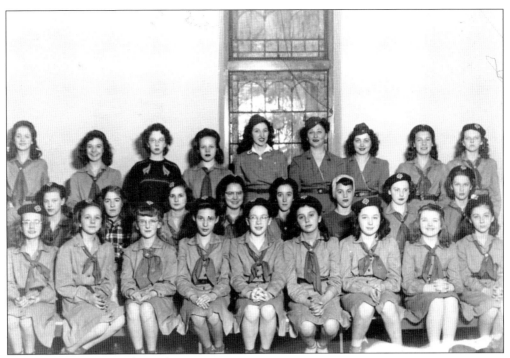

Neville Island supported a Girl Scout troop.

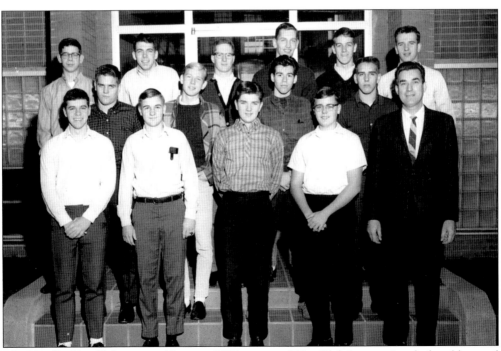

The Neville Key Club, pictured here in 1965, is part of Key Club International, the oldest and largest service program for high school students designed to teach leadership through public service. It is part of the Kiwanis International group and is sponsored by local Kiwanis clubs.

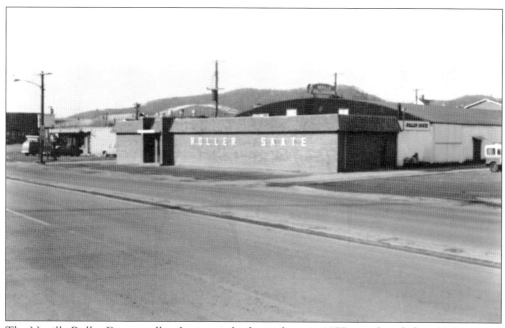

The Neville Roller Drome roller-skating rink, shown here in 1977, was founded in 1948.

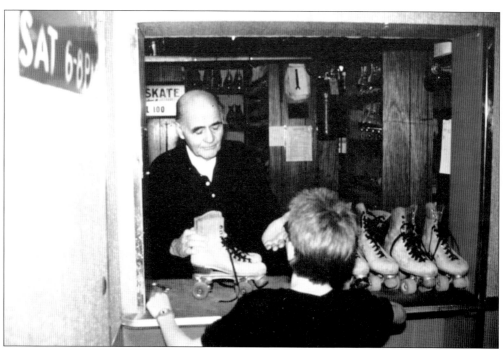

The co-owner of the rink, Tony Deramo, is actively engaged in running the rink.

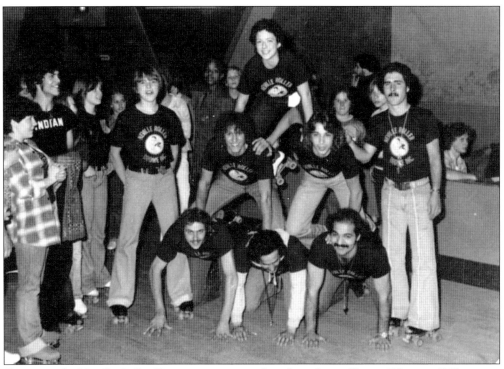

Skaters at the Neville Roller Drome raise money for a Jerry Lewis Skate-a-Thon in 1977.

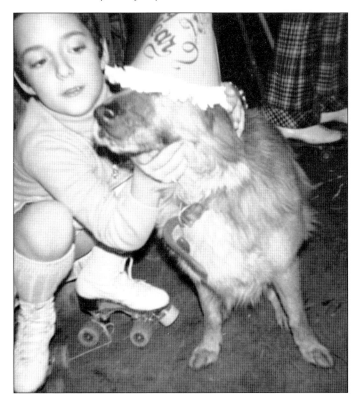

Nancy Deramo and her dog Ringo are seen here in 1968 at the Neville Roller Drome. Ringo was a common sight at the rink.

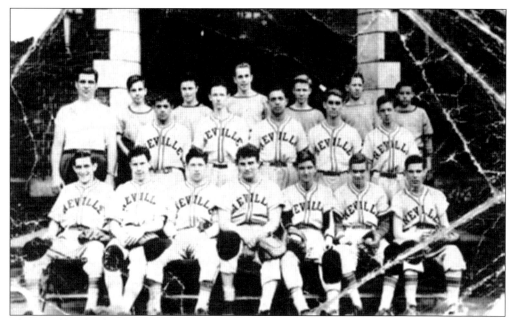
The Neville Island School supported a baseball team, pictured here in front of the school.

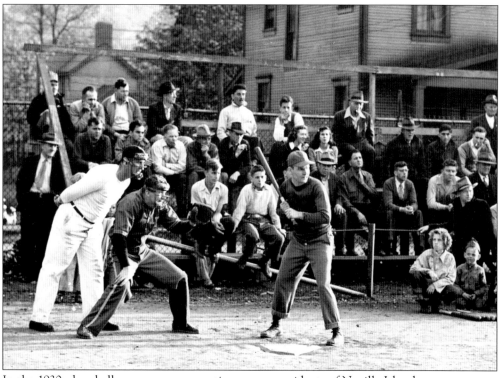
In the 1930s, baseball was a common pastime among residents of Neville Island.

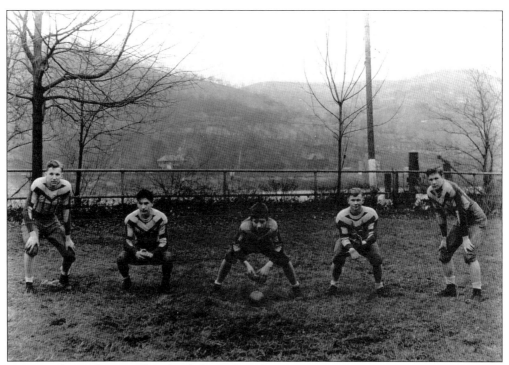
Five members of a Neville Island football club pose for the camera close to the river in March 1937.

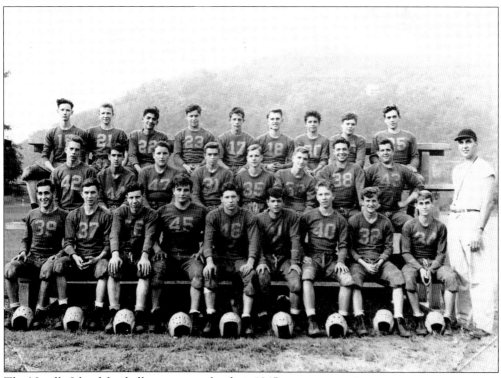
The Neville Island football team poses for their 1945 season team picture.

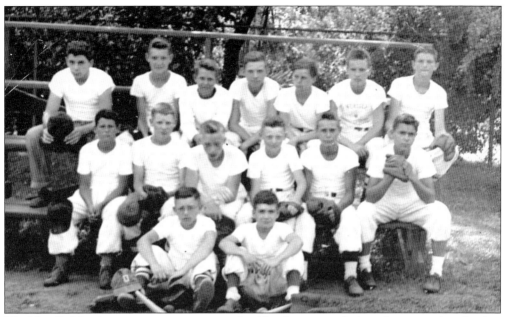
The Neville Island recreation program was a healthy distraction for boys living on the island.

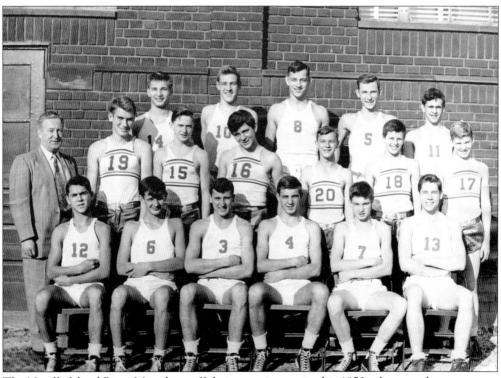
The Neville Island River Men show off their team jerseys in this 1950s photograph.

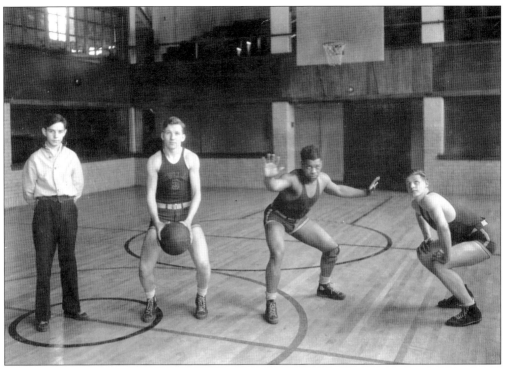
Three members of Neville Island High School's basketball team prepare for a game.

Basketball was a popular activity for Neville Island High School students, seen here in 1937.

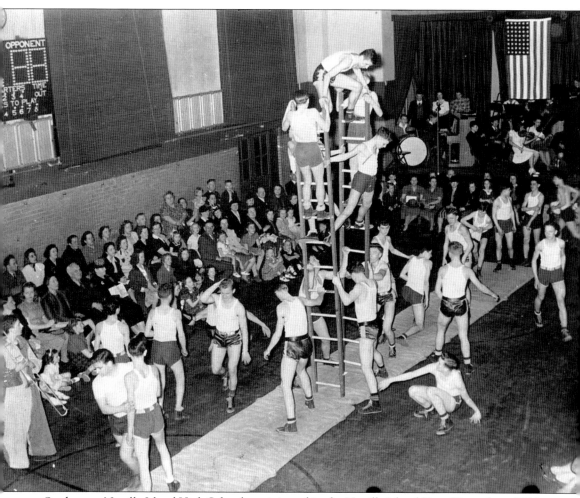

Students at Neville Island High School participated in the Neville Island Gym Circus from 1926 to 1942. Each class performed an act for three days. Capt. Jack Foley, who was head of the Boy Scouts for 23 years, served as the clown. This photograph shows the students performing an act on ladders in 1938.

Eight
PEOPLE AND PLACES OF THE ISLAND

Dorothy Antonelli, resident of Neville Island and president of Neville Green has said, "Neville Island has great diversity as it is heavily industrial at one end, but pleasantly residential on the other end." The people of Neville Island show a demonstrated history of love and dedication to the island despite the challenges and adversity they have endured. The island's captivating ambiance grasps the hearts of the islanders, and the river makes the area a compelling destination.

At the waters edge, stories have been buried and resurfaced by the sands of time. Residents speak of long-ago stories, when in the early 1900s, children watched floodwaters rise, and little girls carried their dolls to safety trying to protect them. The stories continued about the days of islanders, who sunbathed on the natural beaches, and about stories such as relics like arrow heads being found from the Native Americans who the first inhabited the island. Often islanders have been inspired by the river to create works of art such as poetry.

The island's diverse history reflects generations of pioneering efforts, vision, and the people who settled the land. Over recent years, many articles in local newspapers have continually spoken of revitalization plans for the island. Today the many hopes and dreams of both Neville Island and Pittsburgh residents include the wish to see revitalization efforts begin for the return of the "Gem of the Ohio" to preserve not only its past but also create a bridge to a vibrant future.

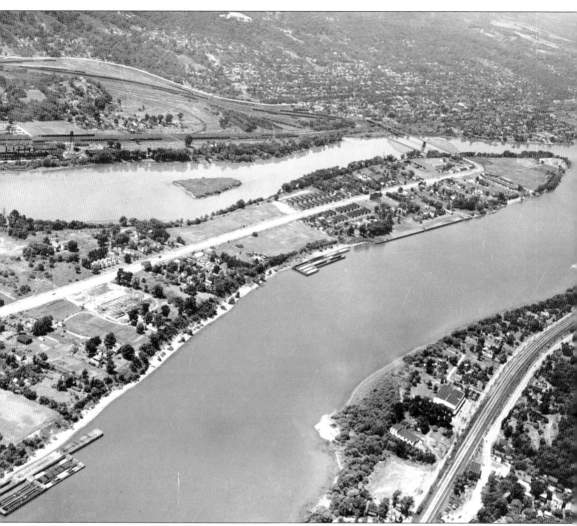

An early 1940s aerial photograph of the west-end tip of Neville Island depicts the beautiful hillsides of the west hills, homes from the neighboring community of Coraopolis, and the lost Sunshine Island. The vastness of trees is no longer visible, as they were washed away by the 1936 flood. Around Sunshine Island's edge, only small bushes are visible, as vegetation is growing just a few years after surviving the 1936 flood. Residents either swam or boated to Sunshine Island. They had picnics, pitched tents, held cookouts, and had campfires on the island. Boat races around the island sponsored by the Greater Pittsburgh Aquatic Club were held each year. As lovely as this island was, it was destroyed by the last major flood in 1972, which resulted from Hurricane Agnes. Once the floodwaters receded, not much was left of Sunshine Island except a muddy mound. The area was dredged and the island is only now left as a place in history.

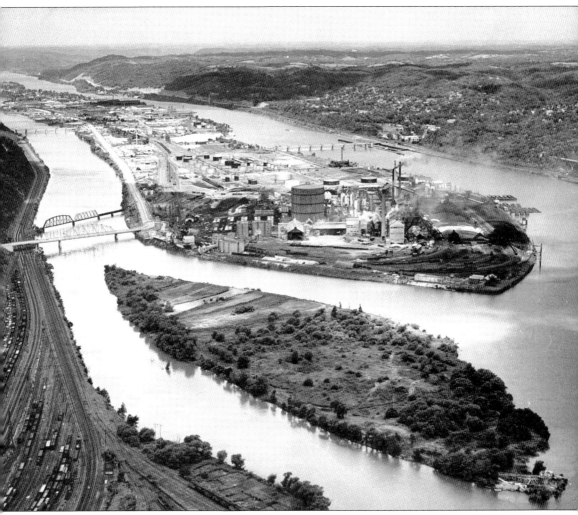

Seen in this aerial photograph is the east end of Neville Island. The appearance of booming industry is apparent, along with Davis Island. Marie Watters, who was born in 1910 and spent her life as a devoted schoolteacher, was said to have grown up on Davis Island. Her family had a farm there and are the only known inhabitants of the island. When she was a young girl, she took a boat to Neville Island and walked nearly three miles to go to school each day. She and her family eventually had to move from Davis Island onto Neville Island as a result of the river dredging to accommodate the large industry boats that shipped to and from the island. Before this, the area between the two islands was more like a deep creek. Currently, Davis Island is owned and used by West View Water Authority.

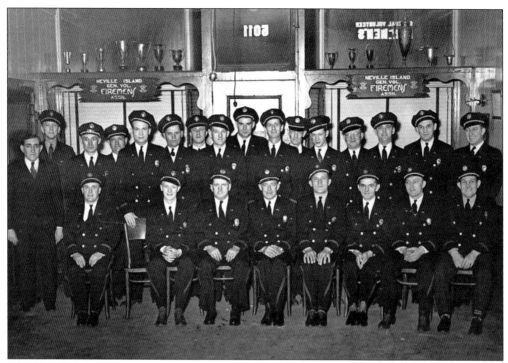

The Neville Island volunteer fire department is seen here along with their many trophies in the background.

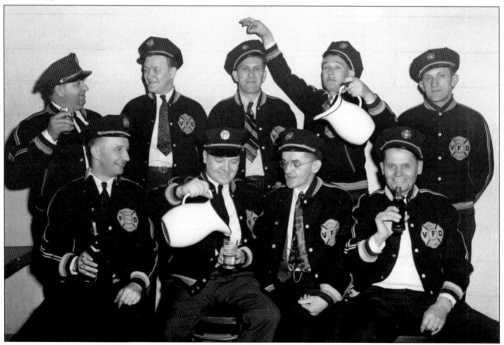

Here the firemen are photographed having some fun. Today the firemen are still very active on the island. In addition to their firefighting efforts, Neville Island firemen also engage in river rescue efforts when necessary.

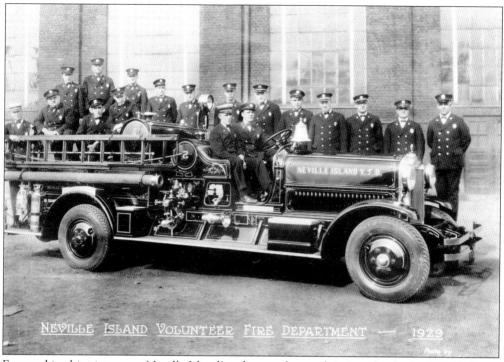

Featured in this picture are Neville Island's volunteer fire truck in its splendor in 1929. Today in addition to fire trucks, Neville Island's firefighters also have rescue water craft.

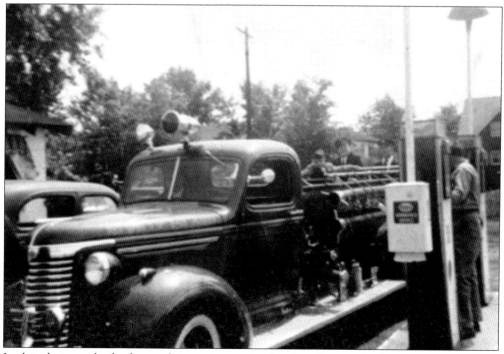

In this photograph, the fire truck is getting serviced and ready to go for the next emergency.

Police Chief Ross Willcock stands for a pose with his son, Donald "Sonny" Willcock.

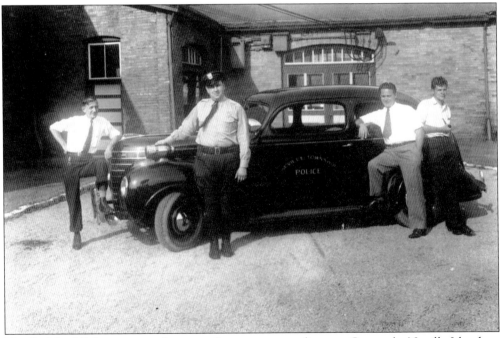
Neville Island Police are seen here standing next to a police car. Currently, Neville Island no longer has its own police department; the island is protected by Ohio Township Police.

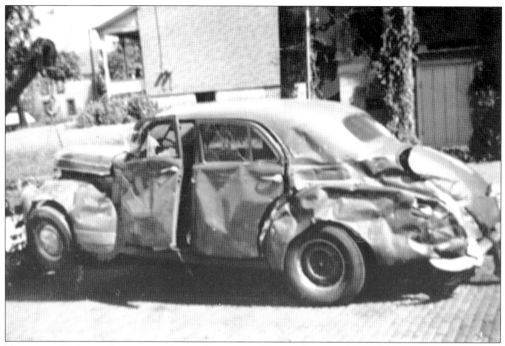

How exactly this police car got banged up is not known, but residents claim it was the result of a police chase on the island.

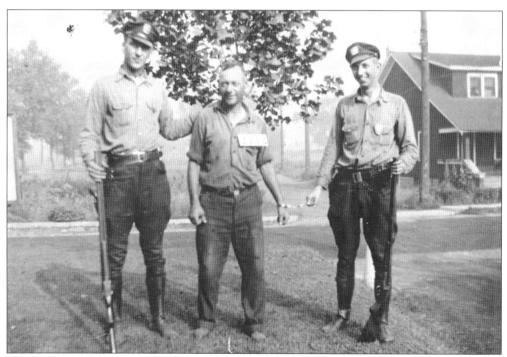

Caught by the Neville Island Police is a criminal who is handcuffed to the officer on the right. Notice that each officer has a rifle in his hand, and the prisoner has been tagged.

Featured in this picture is the police desk room. Standing from left to right are Jack Foley, Richard Rickert, and Earl Wilson. Herbert Bortle is seated.

Members of the auxiliary police force are seen here after just completing instruction. This photograph was taken inside the municipal building on Neville Island. The auxiliary police worked along with the Neville police officers and were prepared for states of emergency.

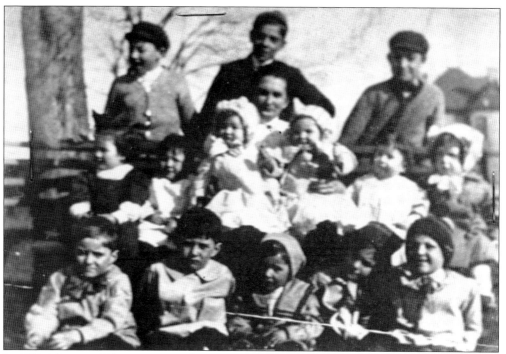
In 1910, Margaret Gibson is pictured on a summer day with her grandchildren.

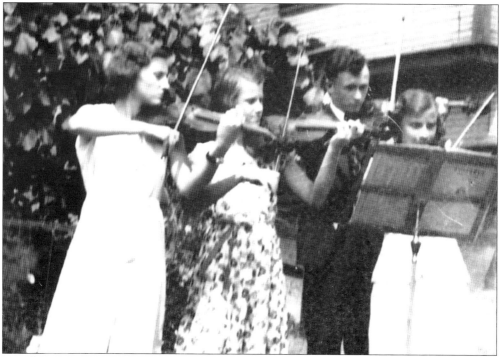
Seen here is Amelia Horak playing the violin with her siblings. Photographed from left to right are Irene, Ruby, Paul, and Amelia.

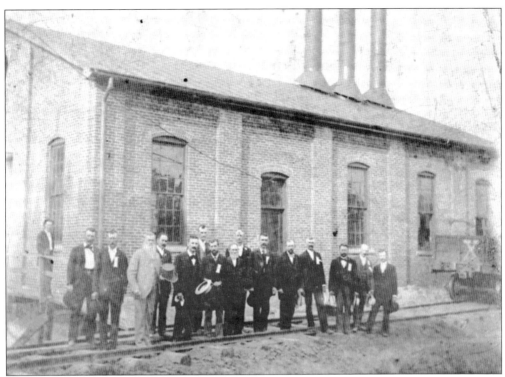
The trolley station was where the trolley and its workers came together.

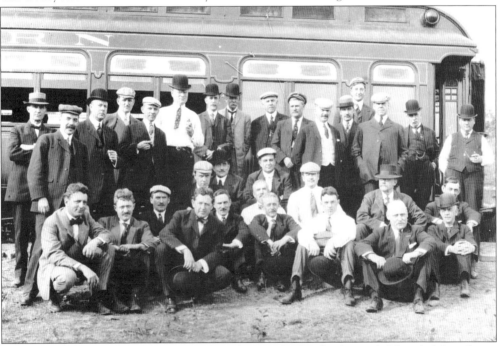
This trolley was uniquely designed. It is the only one of its kind to have a left-handed door due to the riverside being on the right. This trolley can be found in the Pennsylvania Trolley Museum located in Washington, Pennsylvania.

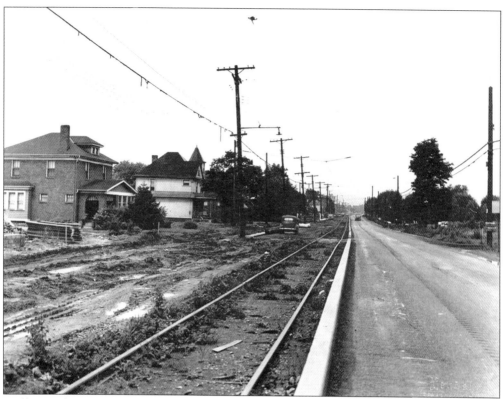
Trolley tracks ran down Grand Avenue before it was a four-lane highway.

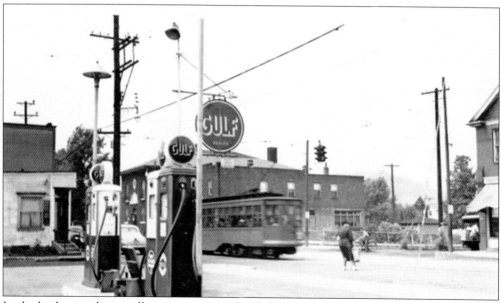
In the background is a trolley zooming past the Gulf station on Grand Avenue.

This playhouse got buried under several feet of snow during the blizzard of 1950.

Cars were stranded for days as a result of being buried in the snow.

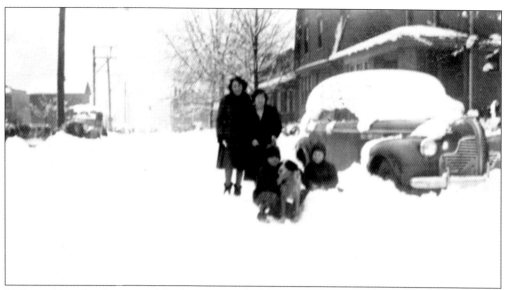
Lads would make the most of the heavy snow by having snowball fights.

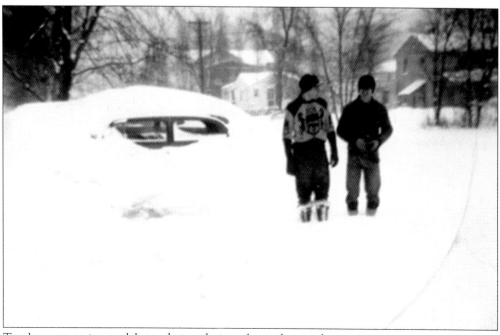
Two boys are trying to debate what to do in order to dig out the car.

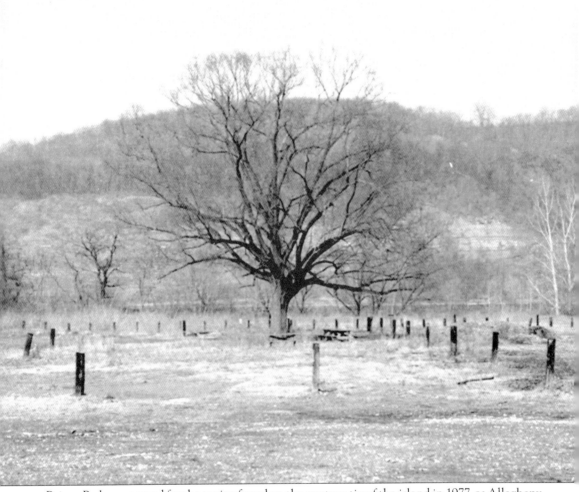

Poison Park was named for the toxins found on the western tip of the island in 1977, as Allegheny County was developing the site for a community park. It was the result of chemicals dumped there from the Pittsburgh Coke and Chemical Company years earlier. Seen here is the beautiful landscape on the west end of the island, ready for the community.

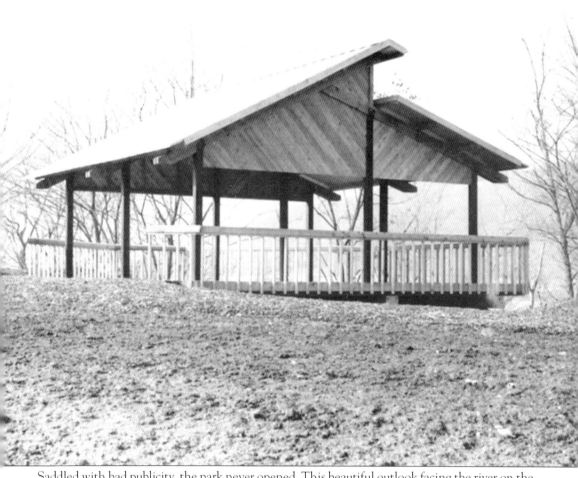
Saddled with bad publicity, the park never opened. This beautiful outlook facing the river on the west end of the island was never utilized and had to be torn down.

This brother and sister have eager anticipation of a community park opening and decide to take a stroll to preview the area just days before the park was found to be unsafe.

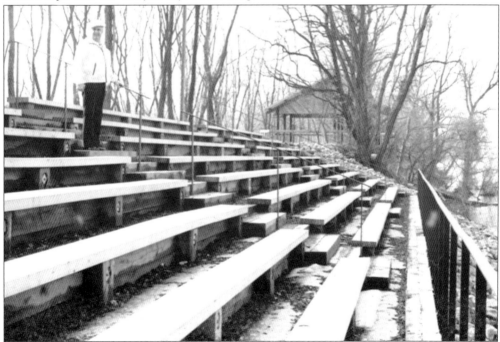
The intent of these bleachers was to invite entertainment, such as musical orchestras. Other plans involved creating access to the river for swimming. Despite the negative publicity created by the situation, Neville Island continues to flourish as a clean, environmentally-sound community.

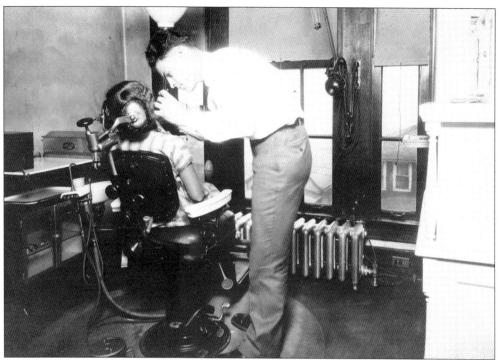

Most children visited the dentist at least once a year. However, many only went when a tooth was decaying.

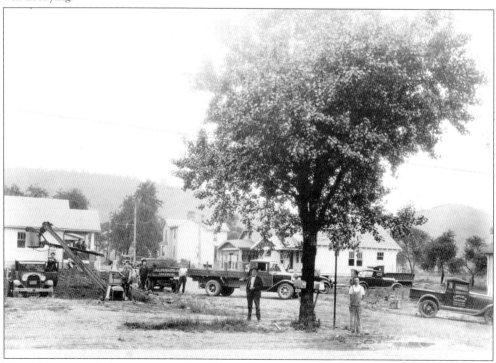

These houses are being constructed on the corner of Grand Avenue and Orchard Lane. They are still located there today.

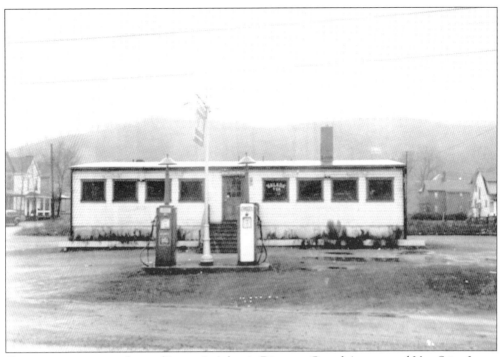

Gas pumps are seen in front of Ingram's Atlantic Diner on Grand Avenue and Von Stien Lane. A 7-Eleven store stands there today.

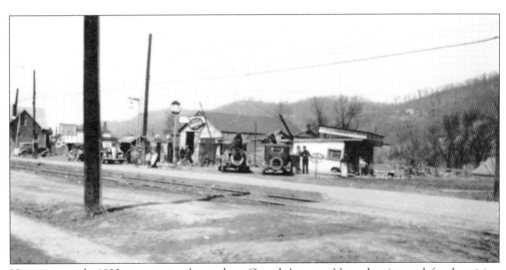

Here is an early 1930s gas station located on Grand Avenue. Note the sign at left advertising Gibson's vegetable plants for sale.

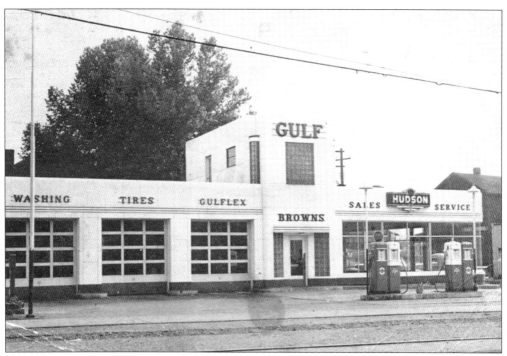

This Gulf station still stands on the island but is now called Neville Auto.

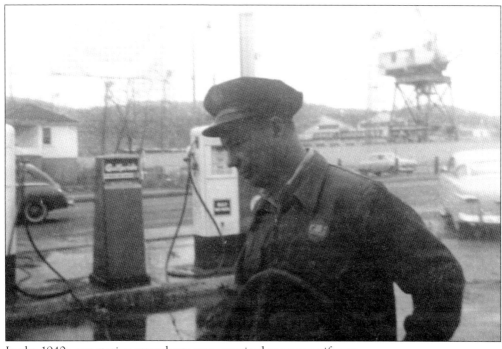

In the 1940s, gas-station attendants were required to wear uniforms.

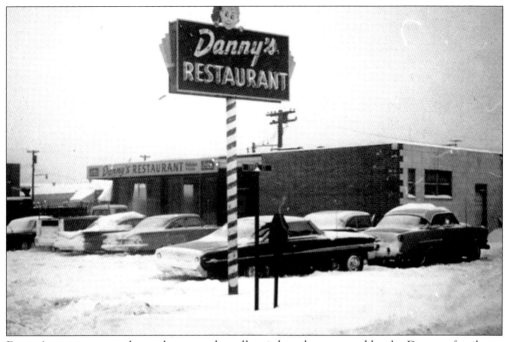

Danny's restaurant was located next to the roller rink and was owned by the Deramo family.

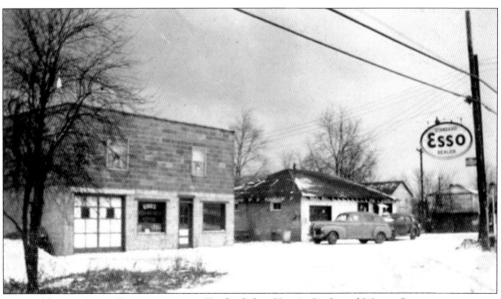

Located here is Ross's Esso gas station. To the left is King's Outboard Motor Service.

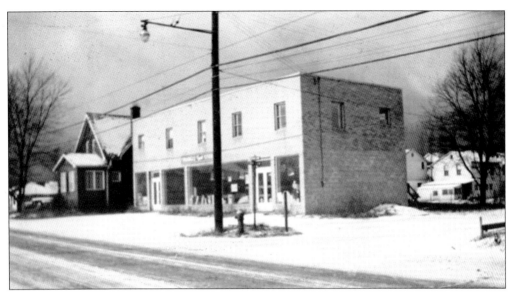

This is the Triangle Food Store on Grand Avenue on west side of the island. Team Sportswear is now located in this space.

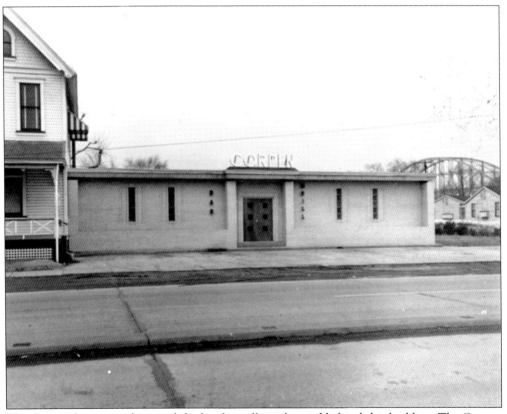

The Corpen bar is seen here and the bowling alley is located behind this building. The Corpen hotel can also be seen on the left side of photograph.

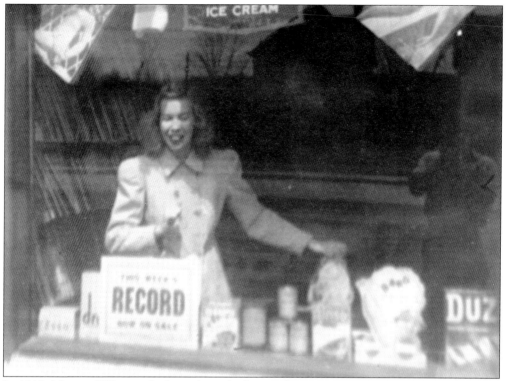

In 1948, Maxine Wilson is looking through the window at Ross's gas station. The *Coraopolis Record* was sold here to residents. Inside was a pool table and pinball machine.

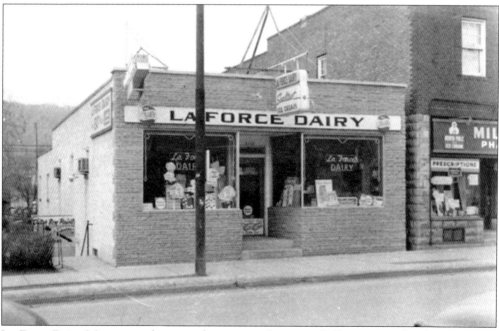

La Force Dairy Mart was a hot spot for teens to hangout. Folks went to the dairy mart for cheeseburgers and shakes. People often gathered here before going to the roller rink.

Miller's pharmacy was also a popular place to go. Barbara (Los) Wilson is seen hanging out. Many youth on the island came here to enjoy the soda fountain.

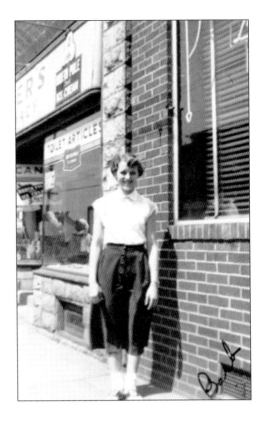

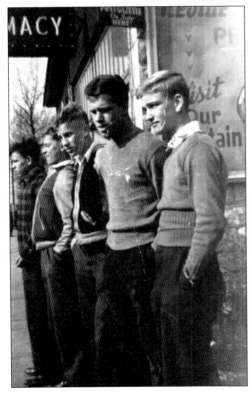

Teens are seen hanging out at this popular spot.

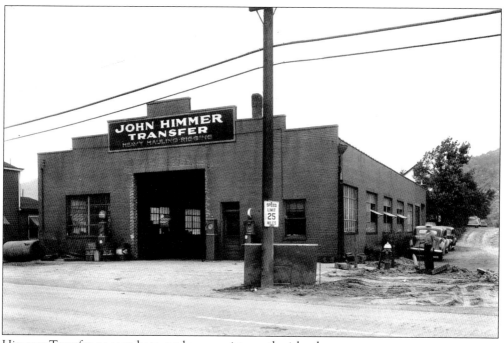
Himmer Transfer, as seen here, no longer exists on the island.

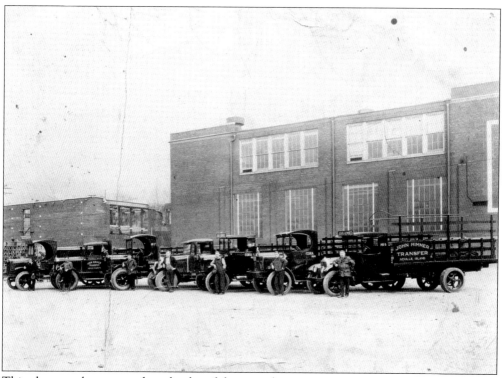
This photograph captures the splendor of these trucks.

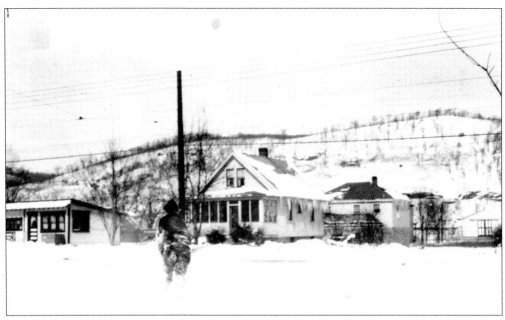
The Clover Farm store, located on Grand Avenue, is seen on the far left side of photograph.

Many folks went to this Wonder Bread outlet and, for under a dollar, walked out with several bags of cupcakes, loaves of bread, pies, and muffins.

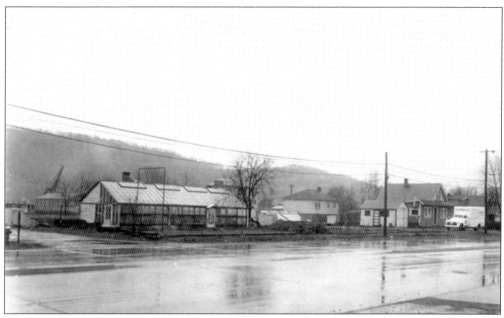

Local resident Dr. James W. Giacobine Jr.'s family owned this greenhouse, and it was known as Giacobine's. Experiencing financial stress as a result of the depression, Giacobine's mother utilized the organic resources of the island as an attempt to save their home. His father built a greenhouse in the back yard, and the family began growing tomatoes and flowers. A Heinz truck can be seen in the background.

Eventually, with encouraging results, the family purchased several acres of land on Vivianna Way that extended to the riverbank in order to construct a large greenhouse. Flowers were sold to residents such as the Mellons and Scaifes. The greenhouse was damaged by a fire many years later.

These houses on Grand Avenue were torn down as a result of the Interstate 79 construction. Residents felt forced from their homes, and most did not think they received a fair price for their property. Residents were notified by letter that they needed to surrender their property as a result of the construction. Although some time was given, residents did not want to lose their property.

In the case of one woman, her husband was sick with cancer, and she had small children to care for. He died before it was time for her to move. After appealing to Ryan Homes to build her a new house, they did so, and it is now the only existing Ryan Homes structure on the island. In 1900, homes had a base price of $500.

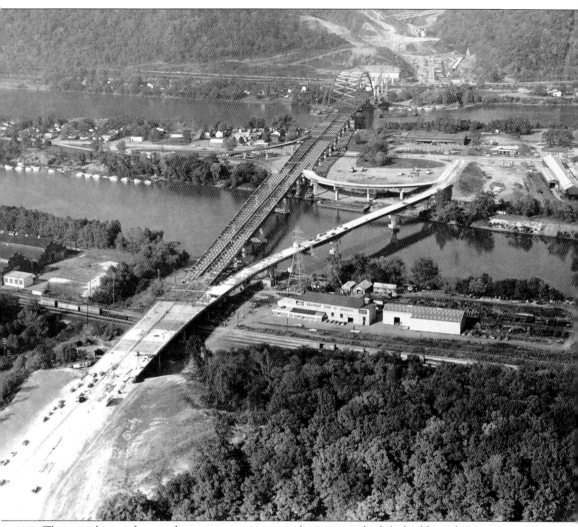

This aerial view depicts the major construction that occurred while building the interstate. A total of 61 homes had to be demolished, and several were moved and relocated. Construction of Interstate 79 took place between 1971 and 1976. Planning for the Interstate 79 connector between Washington and Erie was originally approved in 1955. Construction officially began in 1971. It was designed to be a western bypass of Pittsburgh that connected with east–west highway Interstate 80. (Courtesy of Library and Archives Division, Sen. John Heinz History Center.)

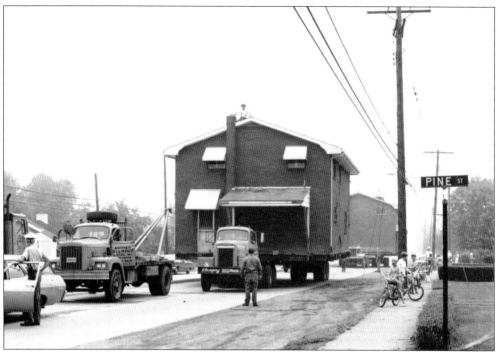

The moving of this brick house was in response to the construction of the interstate. Notice the man on the roof providing direction to those below. Children stood on the side of the road to watch the massive move.

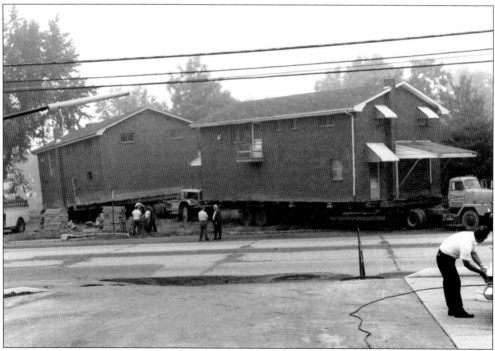

Curtains can be seen still hanging in the windows as these homes are being relocated. They were moved under the guidance of a police escort.

The construction of the Mansionettes can be seen in this 1950s photograph. They still stand today and provide affordable living for many families on the island.

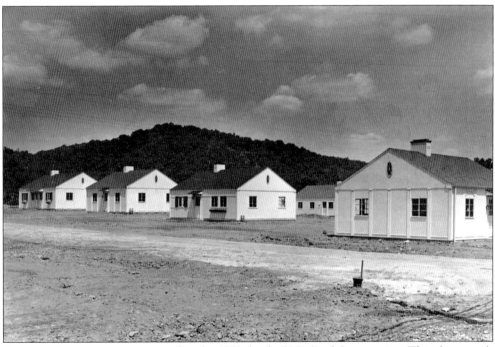
Gunnison homes were constructed in the 1950s by the U.S. Steel Corporation. This photograph was taken on June 11, 1950.

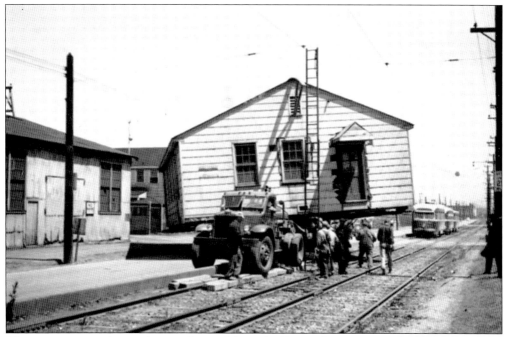

The structure seen here is being relocated from the Dravo Corporation to its new location on Walnut Street. This was once an infirmary for Dravo before the Williams family purchased the building. In this photograph, the workers almost lose the house, as it steeply tips and swings to the left.

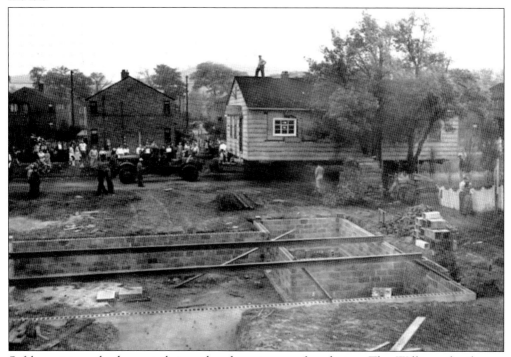

Safely arriving, the home is being placed on its new foundation. The Williams family was well-known to residents of the island, as they delivered the daily newspaper for over 20 years.

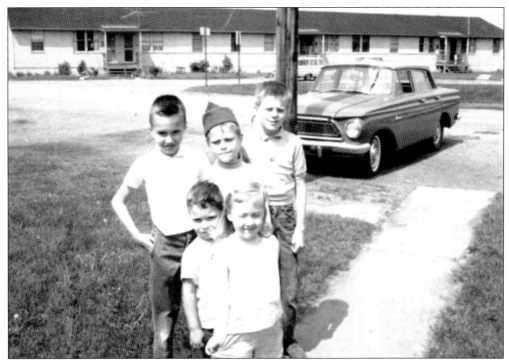
Children are seen here standing outside the barracks. These barracks were built during World War II.

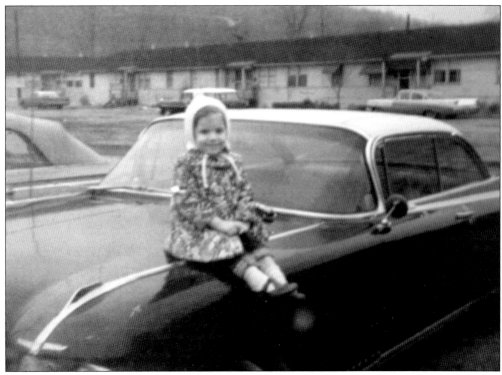
A small girl sits on a car outside her residence at the barracks.

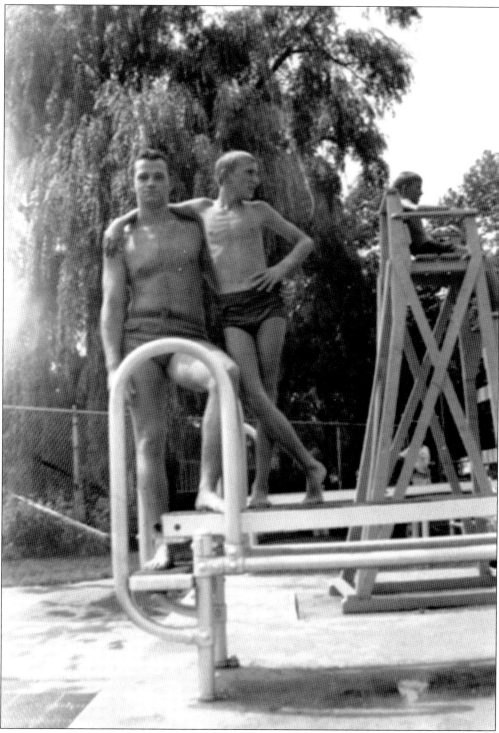

The Dravo Corporation pool was built specifically for its employees. Residents of the island were welcome to swim at no charge as long as they were registered and sewed a small, metal tag onto their swimsuits. The pool closed many years ago.

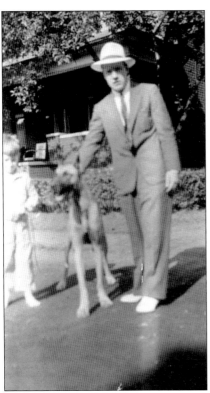

James Pentland is a longtime resident of the island. Here he is photographed along with his dog. Pentland was known best as a community leader on Neville Island and served on the township's board for many years.

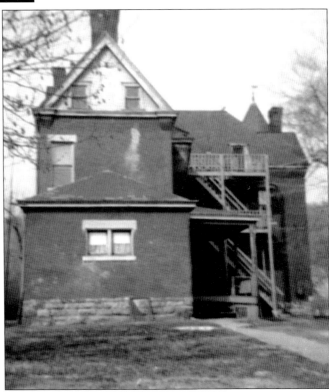

This photograph depicts one of the mansions of the island.

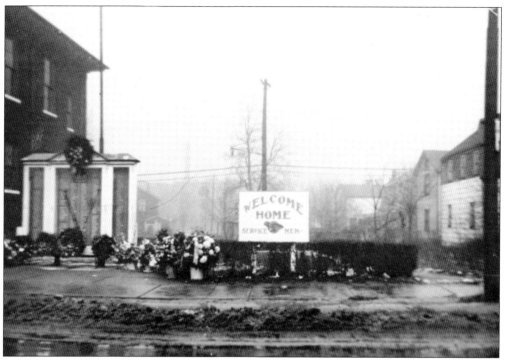

A memorial was placed next to the police station to welcome home servicemen. A permanent memorial is located in Memorial Park.

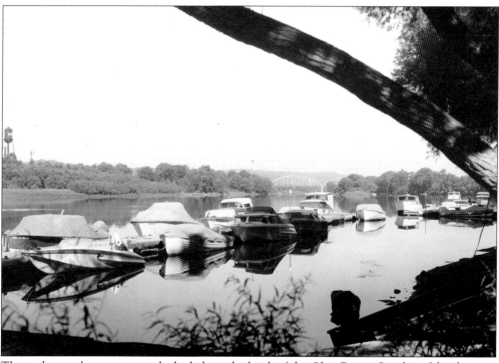

These pleasure boats are seen docked along the bank of the Ohio River. Sunshine Island is seen in the background on the far right.

These gentlemen are enjoying festivities at Corpen.

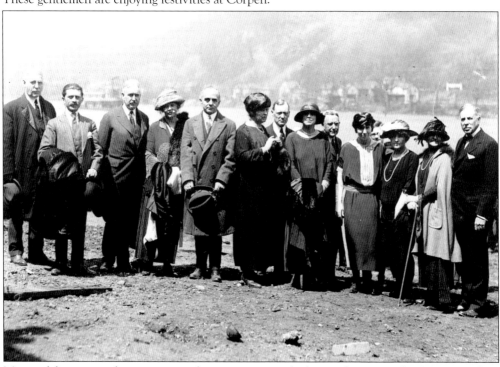
Many celebrations and ceremonies in the community took place at the river's edge. Men wore their best pin-stripped suits for these events, as the ladies sported lovely hats and beaded necklaces.

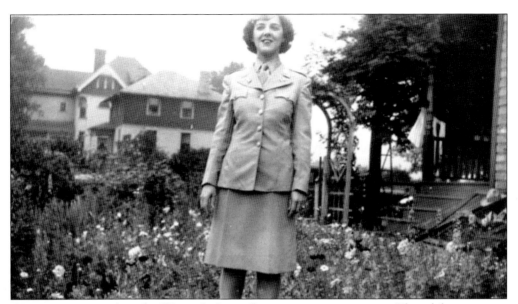

Women participated in the Women's Army Corps service opportunity. They did not receive commission while doing so.

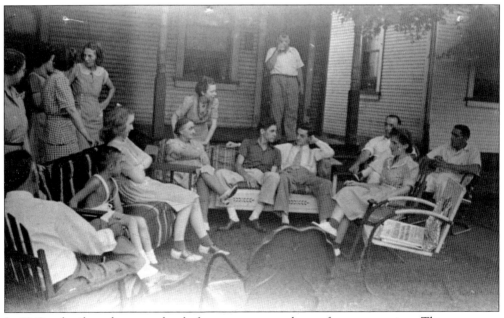

In 1943, a family gathers together before a young man leaves for army services. The newspaper on the chair (right) has wartime headlines.

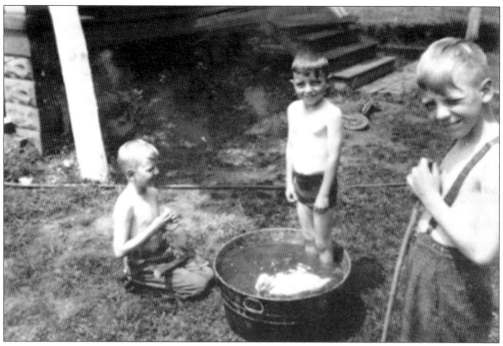

Seen here are some young children having some summer fun with a wash tub and a duck.

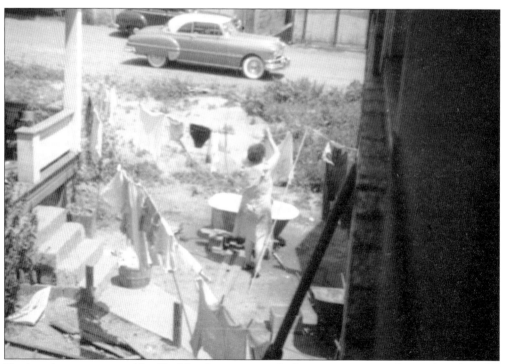

During the summer on Neville Island, women took the opportunity to hang their laundry outside to dry. In this photograph, a bathtub can be seen outside in the yard.

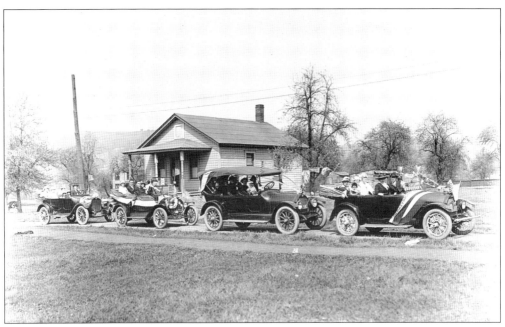
It may look like a parade but it is not. Seen here are folks selling war bonds in the early 1900s.

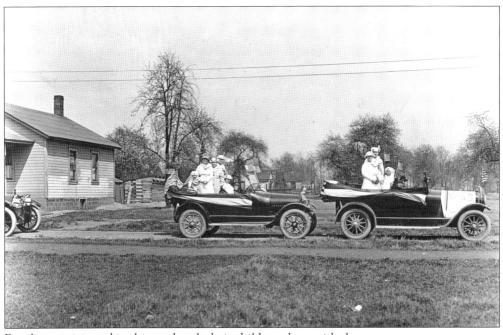
Families participated in this, and took their children along with them.

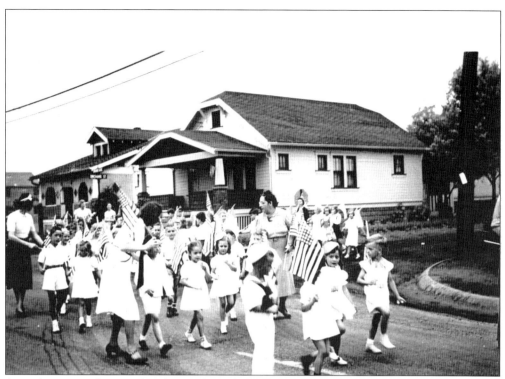
A teacher is seen here guiding her students for a rare parade on the island.

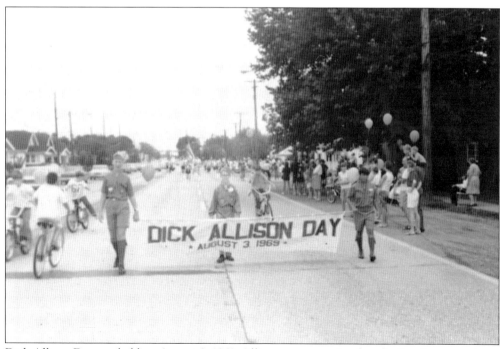
Dick Allison Day was held on August 3, 1969. Allison was committed to the Boy Scouts and was very instrumental in the community and the Neville Island Presbyterian Church.

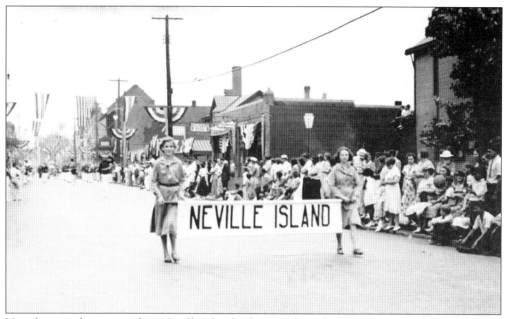

Very few parades occurred on Neville Island. This parade took place in 1937 in the neighboring town of Coraopolis for the community's semicentennial parade celebration.

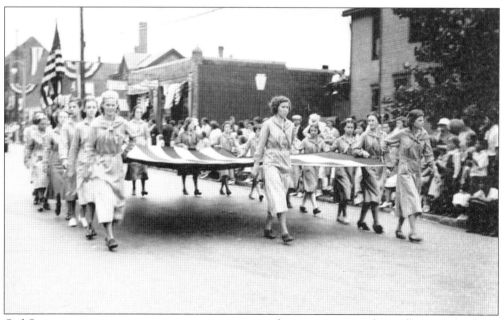

Girl Scouts were active participants in representing the community and proudly carry this large flag. The semicentennial parade had to be postponed for one year due to the damaging floods of 1936.

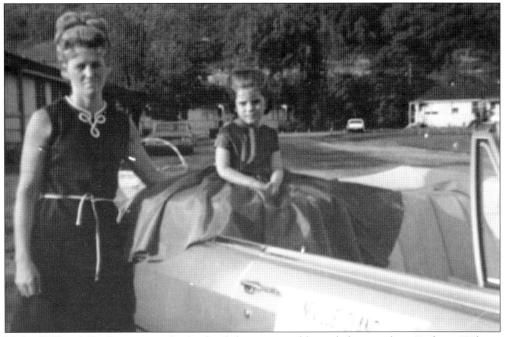

Vicki (Wilson) Fiedler sits on the back of this convertible with her mother, Barbara Wilson, preparing to participate in a parade. Fiedler was selected as Neville Island's Fireman's Queen. Behind her is a basket filled with candy to throw out to bystanders.

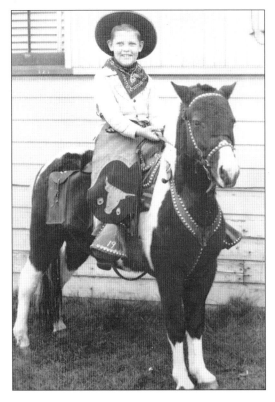

A photographer traveled to Neville Island each year to take photographs of children on a pony. Coney Island Park also took photographs of children and offered pony rides.

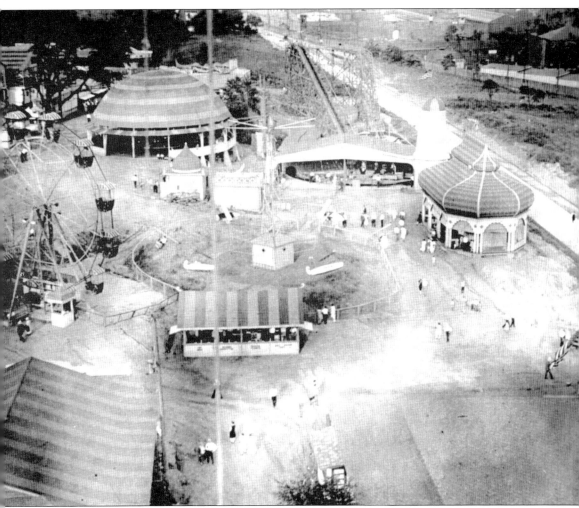

In 1907, a new pleasure park called Coney Island opened on June 27, 1907. "Cool Coney Island" on the "O-HI-O" featured a 50-foot boardwalk, a skating rink, a shoot-the-chutes ride, a dancing pavilion, a merry-go-round, a playground, a pony track, and a 1,000-foot beach. According to newspaper accounts of the time, it was a very popular attraction for people in the Pittsburgh area, opening a few years after the more-enduring Kennywood Park. While it opened to great acclaim, Coney Island Park was undercapitalized, and its full vision was never completed. It disappeared from the island shortly after 1910.

Across America, People are Discovering Something Wonderful. Their Heritage.

Arcadia Publishing is the leading local history publisher in the United States. With more than 3,000 titles in print and hundreds of new titles released every year, Arcadia has extensive specialized experience chronicling the history of communities and celebrating America's hidden stories, bringing to life the people, places, and events from the past. To discover the history of other communities across the nation, please visit:

www.arcadiapublishing.com

Customized search tools allow you to find regional history books about the town where you grew up, the cities where your friends and family live, the town where your parents met, or even that retirement spot you've been dreaming about.